GRADIENT LIGHT

The art and craft of using variable contrast paper

by Eddie Ephraums

AMPHOTO BOOKS
an imprint of Watson-Guptill Publications/New York

Photographs and text ©1994 Eddie Ephraums & Working Books Ltd

First published in the United States and Canada in 1996 by Amphoto Books, an imprint of
Watson-Guptill Publications., a division of BPI Communications, Inc.,
1515 Broadway, New York, NY 10036

First published in Great Britain in 1994 by Working Books Ltd,
23-24 George Street, Richmond, Surrey, England, TW9 1HY

ISBN 0-8174-3925-0

Origination - Valhaven, Twickenham, England.
Printed & bound in China by Regent Publishing Services

I would like to thank the following companies for their generous support of this project

Ilford Anitec Ltd
Silverprint Ltd
Keith Johnson Pelling Ltd
Leica Uk Ltd
All the pictures have been made using a Leitz Focomat enlarger

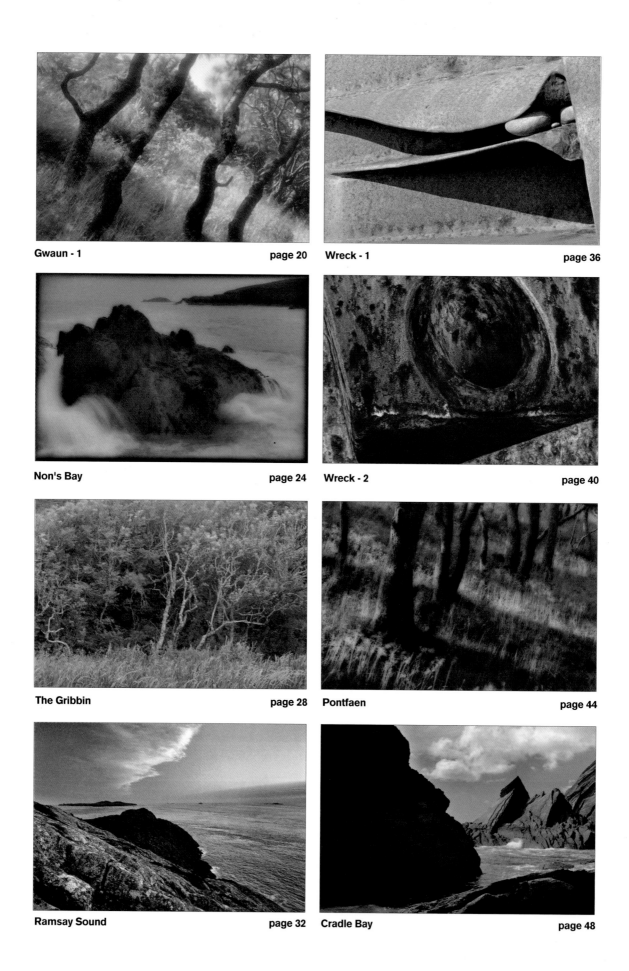

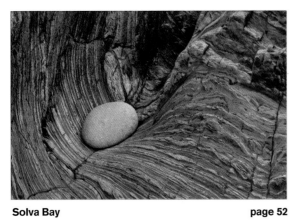

Solva Bay **page 52**

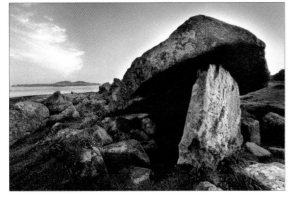

St. David's Head **page 56**

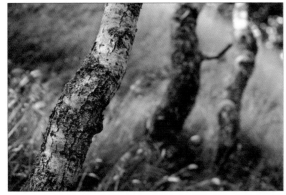

Gwaun - 2 **page 60**

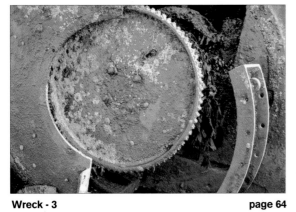

Wreck - 3 **page 64**

Contents

Introduction

Photographic convention

Our photographs should be capable of bringing subjects into 'focus' so others can see them 'clearly', share the experiences with us and perhaps learn something new from these encounters. But this doesn't mean that our images always have to be sharp, or especially fine-grain, or that they should conform to other technical means of expression, if they are to be appreciated or understood.

For example, instead of using a traditional black and white graded paper, perhaps coupled to the familiar Zone System of exposure control, we now have at our disposal a number of very high quality, exhibition-standard, Variable Contrast (VC) papers. These offer far greater flexibility, scope and expressive freedom to the clear-meaning photographer/printer who is keen to push back the boundaries of photographic convention, far beyond what to date has been possible with the more limited fixed-grade varieties. I have found this to be true even when these VC's are used with the supposedly 'inferior' 35mm format: tradition has long dictated that to get the very 'best' results, individual subjects need to be exposed onto separate 120 format rolls, or individual sheets of b&w film, each being exposed and developed according to the subject's brightness range. This rule no longer applies.

The idea behind the 'old' fixed-grade system is to make the density range of the negative fit exactly the printing range of the fixed-grade paper. However, this system is restricted to a rather linear, two-dimensional rendition of the subject's tonal values which, to put it rather crudely, merely allows the expansion or contraction of these values to fit the shape (the characteristic curve) of a manufacturer's fixed-grade photographic paper. Now, with VC paper, we can control the image in a third, extra, more individual dimension, by various means of enlarger filtration contrast control, to alter the subject's tonal values either overall or locally, to make the subject look the way we intended and not necessarily the way nature, or the quality of light, or the fit of a paper dictates. This applies to all subject matter, not just to the type of photographs depicted here.

A change for the better

In fact, no matter what format of camera we use, with VC papers I would say we have never had it so good, more so if we are prepared to judge the quality and content of our images by our <u>own</u> standards rather than by those dictated by photographic convention. Naturally, this requires a clear understanding of what each of us, as individuals, are trying to 'say' with our photographs and that in turn requires a healthy but certainly not obsessive understanding of materials, methods and techniques to enable us to express ourselves clearly. The division of the book into two halves: firstly, the photographic examples, then the technical/practical section, is an attempt to make this point clear.

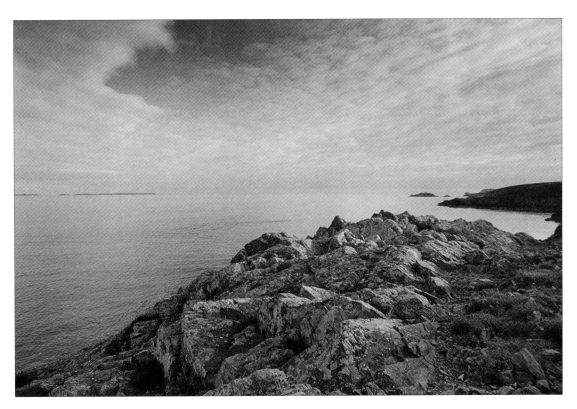

St Non's Bay, South Wales.

This picture is a good example of some of the benefits to be had from working with Variable Contrast paper. To enhance the separation of the clouds, I printed-in the sky at a higher contrast grade setting. In contrast, the bright, specular highlight to the right has been printed-in at a lower contrast setting to add extra, much needed detail - but without building up density and contrast - to avoid the halo effect, visible in the smaller print. The latter (although slightly exaggerated for reproduction purposes) is typical of the result we can expect if we burn-in certain areas of a print at the same grade setting, for example as if we were working with fixed-grade papers.

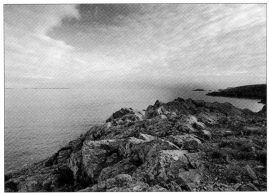

A panoramic picture from St. David's Head, close to where the photograph on page 57 was made. I chose a 50mm lens, as opposed to an extreme wide-angle, quite simply because the distortion of the latter would have grossly exaggerated the natural curvature of the horizon that was central to the success of the image. However, a single wide-angle negative would certainly have been easier to print. I metered the scene at its extreme left, pointing the camera down, so that its centre-weighted meter wouldn't be confused by the brightness of the sky. I then exposed all the negatives at the same camera setting, using an orange filter. A polariser would not have been suitable, since its effect would not have been consistent across the scene, making the prints potentially hard to balance.

To make the print, I first made various test-strips of three of the negatives: of the extreme left, the center and the extreme right images. I opted for a contrast setting that gave the right balance of shadow and highlight detail in the two outer images, basing my exposure time on the brightest, central picture. What I didn't want was to create a series of prints that all matched exactly; I wanted the images to get naturally darker towards the edge of the scene. Only a couple of the prints required slight exposure modification, in particular the extreme left image needed its right side dodged, which I did with a sheet of card, moving it gradually back and forth over the paper. All the prints were developed for the same x5 development factor. I avoided toning the prints: trying to get eight separate prints to match in colour is not easy.

Visualising the image in Variable Contrast

Through 'Gradient Light' I hope to demonstrate how, as photographers/printers using VC paper, we can visualise our prints even more effectively at the camera exposure stage of the photographic process. Then, I hope to be able to show how we can learn to improve upon this view through the combined use of VC techniques - particularly with reference to Ilford's Multigrade fibre-based paper which is my preferred variety, especially the matt version.

Through various exposure, bleaching, re-developing and toning techniques, I hope to demonstrate how Multigrade can also be used, like most brands of VC, to emulate other makes of paper: old, new, cold and warm-tone, saving us both the cost of buying other makes and also the inconvenience (the distraction?) of learning to work with them.

Getting to know one paper really well, as I have tried to do with Ilford Multigrade, is like having just one camera and using it with a meter: simplicity keeps us focused on the job in hand. Using just one make of paper combined with the use of test-strips (the darkroom's equivalent of the camera meter) enables us to judge to better effect exactly how to expose the print to its fullest potential, to record our subject as we intended. It really would be a wasted opportunity if we allowed the greater potential of VC paper to be seen just as a license for poorer or more indifferent camerawork, although their use certainly enables us to work, to good effect, with otherwise impossible-to-print negatives, perhaps exposed under unavoidably bad or extreme lighting conditions.

It should be fairly self-evident that I find it hard to separate the words 'photographer' and 'printer', especially now we have VC's. Ideally, they should be one and the same person - a 'printographer' perhaps? We are image makers, not just camera operators or just print makers, and to think otherwise, i.e. to believe that one can hand over the responsibility of one's printing to someone else is, in my opinion, akin to divesting oneself of half, if not most, of the thought, creativity, pleasure and control of the b&w photographic process. Working with VC papers isn't just a darkroom process. 'Gradient Light' isn't intended just as a darkroom book.

A complete process

As an example, if I want to emphasise the shadow detail of a landscape in my b&w print, I might slightly over-expose the film, as conventional b&w practice might dictate, to make more of that detail visible in the negative, for it will now sit further up from the 'toe' of the characteristic curve of the film (see Ag+ photographic volume 4). There it becomes tonally

better separated. But, I can also expose the negative on VC paper using two, separate, basic enlarger exposures, one at a harder than normal contrast filter setting, to separate the shadow detail better still, and the second at a lower than normal contrast setting, to put in the highlight detail with subtlety and without emphasising it too much. This way I can get an even better result than with graded paper.

Yes, if we work with graded paper we can also print the same negative harder, exposing the print for the shadows and then, either burn in the highlights - but this will still be at the same contrast grade setting - which may create a rather harsh result, or we can flash the paper to help put back some of the highlight detail in a more subtle way. But the results will not be as good, or as controllable, as that of working with VC's, even if we have used some other methods of control such as working with various print developers and development combinations, which incidentally can all be used with VC's, as well as the split-grading or flashing just mentioned.

Seeing more creatively

To explain further: let us work on the assumption that as we look through the 35mm viewfinder or at the ground glass image of a larger format view camera (which represent very different ways of seeing) we should be able to see, i.e. visualise, our finished image - the print. In other words, rather than seeing the view for what it is, as with landscape photography for example, we should be able to see in our mind's eye our b&w print of it. Now imagine that rather than having just graded paper we have VC paper, with which we can locally alter the balance and therefore the interpretation and meaning of the scene through selective, local, or even overall split-grade contrast control, using appropriate enlarger filtration. We should all be able to visualise some of the possibilities explained in this book, and hopefully we should be able to see many more besides.

I would like to think that 'Gradient Light' is an attempt to allow practitioners of b&w to see even more creatively and therefore to expand their way of thinking. It is about developing ideas - not just about processing papers. It represents a fresh approach to b&w photography, one that is less tied to convention and more attached instead to personal expression.

Working with VC papers, and thinking about their use at the camera-stage, is a way forward that also represents the way ahead in paper manufacture, for indeed graded papers are gradually on the way out.

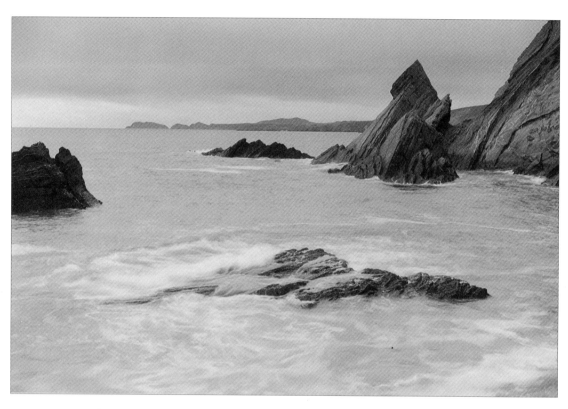

Cradle Bay, South Wales

My preferred image of this subject is on page 49. That picture represents the culmination of several return visits to the same location, exploring the potential of various viewpoints and seeing how different states of the weather and the tide affected the look of the place (as shown in these pictures). For example, of the two pictures on this page, the top is my favourite. Its composition, as affected by the foreground rock and distant cloud formation, is better. The balance of light is also more sympathetic. It emphasises the movement of the water. This is partly due to camera filtration. The bottom image has been polarised.

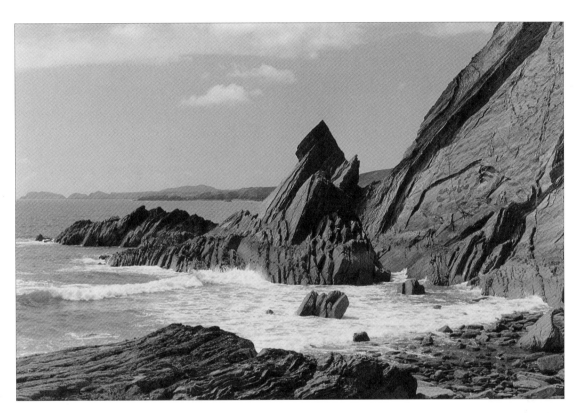

All these prints have been made on Ilford Multigrade VC paper. The top image on page 16 could benefit from further exposure control. For example, to emphasise the central rock, rather than dodge it (which would make it eye-catchingly bright), I would further darken the bottom left corner. To balance this, during the basic print exposure, I would dodge the very bottom right corner and then burn-in both it and the bright patch of water beside it at a lower contrast VC setting. These may seem like minor (unnecessary) modifications, but darken the rock face on the extreme right of the print and then dodge - just a little - the black rock to the left, and the print would be transformed. VC paper and local contrast control makes fine-printing work easier.

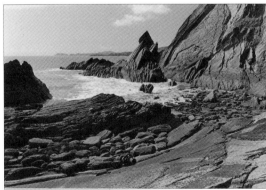

Seeing in Colour - seeing in Variable Contrast

Good photography is about the successful communication of ideas. If we are to succeed in this exchange of 'views', as expressed through the b&w print, then we must learn to see our photographs as others do, for what they really are, rather than for what we think they might be saying.

This is not an easy process to learn; for example, we have none of the benefits of colour transparency photography with which both the photographer and the viewer first see the final image in the same 'positive' finished state. Instead we use a more drawn-out system that involves first seeing a negative image, then a contact print, followed by test-strips and then proof prints before we can even begin to see the actual makings of a final print.

In contrast, colour transparency photography has an immediacy that enables the photographer to look at the processed image as soon as it comes off the machine and to say more easily, "Yes, this image works", or, "No it doesn't". Black and white photography relies heavily on visualisation and decision making skills after the moment of camera exposure, which means trying to create a guiding picture of our final image, in our mind's eye, at every stage of the process. By the time we have gone through all these various (often lengthy) stages of the process we may have got so close to our work that it might be virtually impossible to see the wood for the trees - or the image for the print. Very often a print will end up saying something completely different to what was originally intended and, as the image maker, very often we won't notice this - too distracted have we become by our own perceived idea of that image.

Being decisive

Part of this problem may stem from the fact that perhaps we try to say too much with our b&w images, when maybe we would be better limiting ourselves to the expression of single ideas or 'key' words. For example, how many photographs have we made that contain "pictures within pictures" (views within views - the makings of ideas within ideas) because we have been indecisive and incommunicative with our camerawork or printing? (Look at the two pictures of the Gwaun Valley. Both are very different yet they originate from exactly the same scene.) With many of my landscape images I try to focus on just one 'key' word, using that for guidance at every stage up to and including the making of the final print.

Decisive cropping in-camera is just one tool we can use to begin to overcome this problem of indecisiveness, since it steers the viewers attention in the right direction.

Learning how to balance a print through dodging, burning-in and split-grading (rather than by just cropping) also helps enormously, in a less obvious way. We must learn how to use such tools of communication and to discover what they mean when applied to our own photographic work.

For example, a black border around a print is often used to imply completeness, in an attempt to say: "Look! I've left nothing out, the picture is telling a complete story" (yes, but what story?). It also explains why so many 35mm documentary pictures use this ploy (in an attempt to convey the 'whole' truth). Yet, it's use can be open to misinterpretation: it can dramatically alter the content of a picture, especially if it is used as an alternative to burning-in otherwise large areas of print-white, caused by hard to print-in dense areas in the negative. Such areas may, in fact, contain information pertinent to the image; leaving them blank and putting a black border around them can confusingly make these shapes into subjects of unnecessary attention. Happily for us, working with the split-grade potential of VC's greatly simplifies this problem.

Similarly, by leaving print highlights blank, using the artificially bright whiteness of the paper, to create a sense of light in a print, is, in my opinion, akin to the bare lightbulb school of printing. It is a cheap and easy way of illuminating a print. It rarely makes the picture glow - just glare instead. Except for specular highlights, and the like, light has content: it isn't paper-base white; it has tone, depth, value and, above all, it has meaning. In photography light is our greatest ally - it should be treated with respect and with the enlarger-light filtration of VC's we can do just that.

The language of b&w
In brief, there are few books that explain the grammar of the b&w photographic language, let alone the overall meaning of the language itself (perhaps photography is too much in its infancy). Consequently, many photographers still overly concern themselves with words such as "sharpness" or "granularity", to describe their work, using them as substitutes for real meaning to their images.

I don't claim to be an expert on the language of print communication but I do hope, at least, to raise the subject throughout the book in an attempt to heighten my own and other people's awareness of this often ignored issue. Perhaps, in so doing, it will help to continue to put forward the notion that although a photograph can indeed show everything, it may, disappointingly, also say nothing at all.

Gwaun Valley - 1

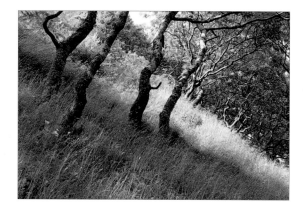 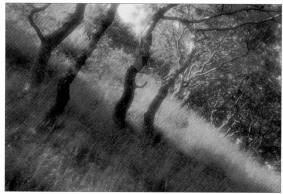

1. An unfiltered colour transparency of the scene, made just after the exposure of the b&w image.

2. A straight-exposure proof print, i.e. with no dodging, burning-in or split-grading.

3. The final print, made on Ilford Multigrade matt, FB, split-graded and thiocarbamide-toned.

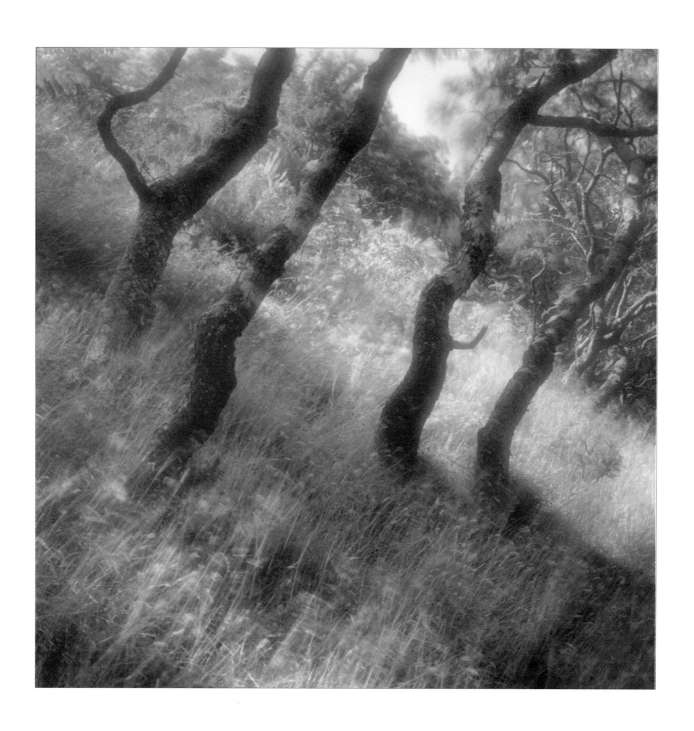

1. Image visualisation

Viewed in colour, the luminosity of this scene relies quite heavily on the bright green foliage of the foreground contrasting against the almost neutral-toned tree trunks that are the main subject. The overly bright and almost white patch of sky, to the top of the scene, doesn't dominate the colour image as it does - very distractingly - in the straight exposure b&w proof print, quite simply because of the intensity of colour contrast of the grass. An almost monochromatic scene such as this makes b&w in-camera filtration decisions much easier. For example, here, the obvious choice is between a green or yellow-green filter. I opted for the latter. Also, there would be little benefit from using a polariser, whilst a graduate filter, perhaps necessary in colour to 'bring down' the sky, would look clumsy in b&w, by over darkening the tops of the trees, rather as if they had been burned in at a normal, rather than at a softer grade $^1/_2$ setting.

2. Camerawork

Visualising this image in VC, I was conscious of the strong backlighting, aware that careful metering (rather than just split-grading the print) was necessary to avoid a print like that above, the result of an under-exposed negative. I metered by pointing the camera down so that it read just the darker, lower foreground. Camera filtration was with a yellow-green filter, that both lightens foliage and gently darkens blue skies. A diffuser helped to add even greater luminosity, spilling light into all the darker parts of the image, but, to cover myself, I also made some exposures without it. It is interesting to compare the two versions. A tripod was essential whilst working with a shutter speed of $^1/_8$th second. The lens was a 55mm micro, set at f11, focused on the nearest tree. The image was exposed mid-afternoon, looking almost due north, with the light coming from the south-west, to the left.

3. Negative assessment

Look at the negatives of this scene on page 83 and you will see why I used no 11. It has more shadow detail and yet frame 9 was 'correctly exposed' according to the camera's meter. No 11 is full of shadow detail, allowing me to dodge the foreground around the trees to enhance the luminosity of this image since it is often detailed shadows (rather than bright, white highlights) that give depth to a print. We can see the right side of the neg is quite dense and contrastier than the main, lower, central part. Some test-strips at grade $^1/_2$ told me how much extra exposure both they and the sky needed.

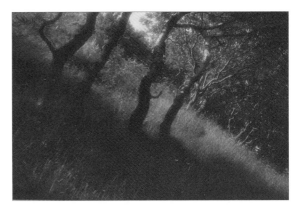

This print is clearly too dark, the result of incorrect camera metering and a negative that lacks shadow detail. This negative, plus others of Gwaun - 1 are shown in **NEGATIVE QUALITY**.

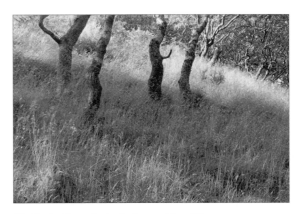

My first attempt at photographing this scene appears almost half-hearted. There is no sky to add depth and the tree-tops have been cropped, spoiling the composition.

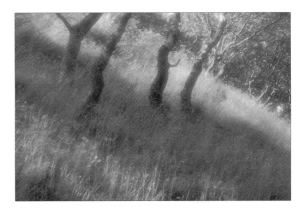

As above, only diffused in camera. This image has been composed as if there was something going on in the foreground, only there isn't. Diffusion has tried to give the image some sparkle - in this case a poor substitute for the real thing.

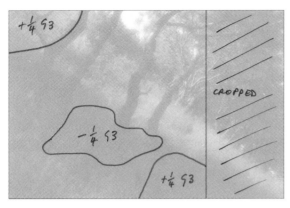

A combination of dodging the central foreground and burning-in the top left and bottom right has given added depth to the print. Burning-in the top left at grade $^1/_2$ (as below) would have left the branch looking too weak.

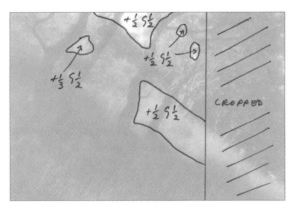

I burned-in the bright highlights at grade $^1/_2$, including some small, distracting areas in the upper right of the print. Using the lower contrast filter darkened these areas without making detail within them too contrasty.

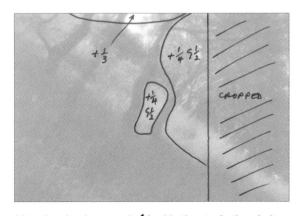

More burning-in at grade $^1/_2$, this time to further darken the central area of grass which looked relatively too bright once the sky had been burned-in. Thiocarbamide toning the print, to make it warm brown in colour, usually requires highlights such as these to be burned-in.

4. Print exposure

There is a slight disadvantage to working with a denser negative (more generously exposed to give well separated and easily dodged shadows): it requires longer print exposure times. For smaller prints this isn't a problem, but for 20x16" prints, made from highly magnified 35mm negatives with the enlarging lens perhaps well stopped-down to cover any misalignment or popping of the negative, it can make print exposure times unmanageably long. So the speed of the paper is important. Ilford Multigrade is one of the fastest. Using VC paper this is a relatively easy print to make, even though it does benefit from two different grade settings. However, the deliberately exaggerated downslope to the right, plus the brightness of that area, required careful burning-in to balance the image, to lead the eye back into the central section of the image. Why did I crop this image? Mistakenly I included the branches to the top right of the full-frame image; distractingly they lead the eye out of, rather than into the photograph.

5. Print processing

I diluted Ilford Multigrade developer 1+9, developing the print to a factor of x6 to ensure development to virtual completion, to make visible, as much as possible, the bright highlight of the sky. I didn't want to lose any density in that area in toning, especially where it blends in to the white print margin. That loss would throw the image right out of balance. With this in mind, I correctly fixed the print for just 2 minutes in Hypam, 1+9, followed by a brief wash, then a hypo clear of a 2% solution of sodium sulphite. Properly washed for another hour (in water at 20C), the FB print was thiocarbamide-toned at the warmest dilution, after just partial bleaching to retain good density in the blacks of the trees. This retention of black was important to maintain good contrast within the image and also to play upon the colour contrast effect of warm-brown highlights against neutral black shadows. The paper was Ilford Multigrade matt FB.

6. Print assessment

There is the odd occasion when you just know a print is going to work, no matter how you print it. This image is one such case. Waiting for the right light, to get the best out of the scene, has meant the burning-in and dodging has been creative rather than corrective - the way it should be. How could I improve upon this image? Certainly not with graded paper. Burning-in the top of the print at the same grade setting makes the tree-tops too heavy, throwing the image out of balance. Knowing I was using VC made composition in camera much easier.

St. Non's Bay

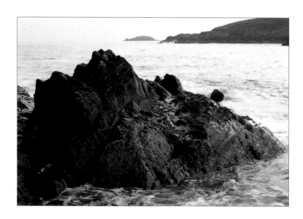 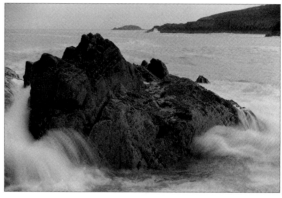

1. An unfiltered colour transparency of the scene, made just after the exposure of the b&w image.

2. A straight-exposure proof print, i.e. with no dodging, burning-in or split-grading.

3. The final print, made on Ilford Multigrade matt, FB, split-graded and gelatin dye-toned.

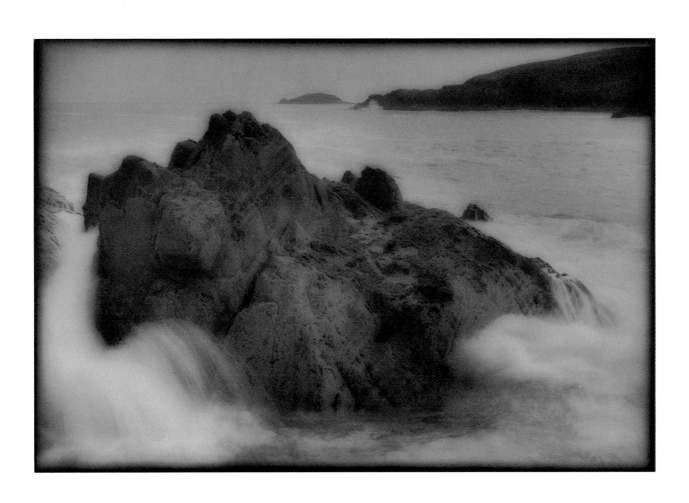

1. Image visualisation

Even in colour, this scene is almost monochromatic. As such, it translates easily into b&w, although any photograph that includes rapidly moving water is difficult to time correctly, especially here since I also wanted to include a wave breaking in the middle distance, against the cliff, to add depth to the print. Although I caught the tide at the right time, the light was not so good. It was coming from the west (to the right), virtually backlighting, rather than sidelighting the main rock. I was unsure if I needed to polarise the image. On the one hand it could usefully get rid of distracting white lines of froth, on the other hand I wanted to retain the wet, bright look of the rock. Polarising the rock would make its dimly lit left side very dark and too dark to dodge in the print. In the end I settled for a yellow and an ND filter. The latter slowed the shutter speed enough to blurr a little the lines of moving froth.

2. Camerawork

Thinking 'VC', I considered a number of printing options before exposing any film. I could split-grade the print, using a brief high contrast print exposure to raise the contrast of the rock, followed by a much lower contrast exposure to soften the background, to create a more three-dimensional image. Alternatively, I could diffuse the image (during printing), to further suppress the distracting patches of froth, perhaps split-grading it as well. The latter option would require a well exposed negative with plenty of shadow separation (perhaps rated at ISO 200), to avoid the left side of the rock blocking up - hence I didn't use a polariser filter. I opted for a 35mm lens, choosing a relatively high viewpoint that kept the tip of the main rock just below the skyline. That way I hoped the image would flow uninterrupted from top right to bottom left and back into the centre of the print. I used a variety of speed settings, not having the luxury of Polaroid to tell me which gave the best sense of movement. I exposed a whole 36 exposure roll. Film is the cheapest part of the process and we learn most by using it.

3. Negative assessment

One quality in particular that I like about XP2 is the way it separates shadow detail so well. The darkest parts of the main rock are alive with detail (even in an ISO 400 neg), still retaining good separation after enlarger diffusion. Because XP2 highlights are finer grained than the shadows (unlike normal b&w negatives), even a 16x12" print of this scene, that is undiffused in printing, has no visually disturbing grain pattern in the large monotone expanse of sky.

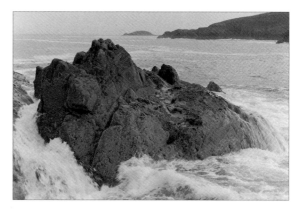

A faster shutter speed and no enlarger diffusion creates a completely different impression of this scene: not only does the foreground water look too static, but that of the middle distance has been rendered too clear.

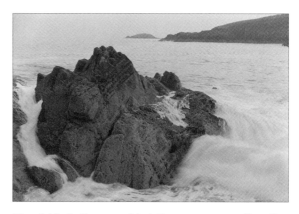

The right shutter speed but the wrong wave. Here the shape of the rock has been completely altered and the compostion thrown off-balance. Note, in particular how much darker the left of the main rock looks in comparison to the larger mass of moving water.

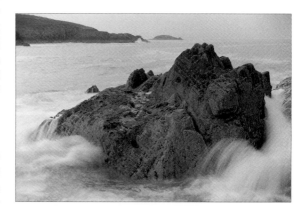

Printed from the same negative as that used for the main picture on page 25, but viewed here in reverse. Looking at a print in this way (with a hand-held mirror) provides useful clues about print balance and composition, by providing a fresh impression of the scene.

Although naturally very dark, dodging the top left of the rock during the basic grade 1 exposure has prevented the image from looking very unbalanced.

Changing to a lower contrast filter, with the diffuser still in place, I burned-in three key areas of the print. Darkening these has helped to make the flowing water stand out more clearly without having to dodge it, which would lose valuable highlight detail.

I burned-in both sides and the top of the print using a very low contrast grade 0 filter setting, still with the diffuser in place. This extra exposure was intended to hold in the lighter sides of the print where they contrasted with the darker black border.

4. Print exposure

I just wanted to convey a sense of movement and atmosphere, to create a restful (not imposing) image. This I decided to achieve by a combination of camerawork (slow shutter speed), VC print exposure techniques (split-grading and diffusion) and toning (a dye as opposed to a chemical blue toner). Having made a test-strip without diffusion, I then increased print contrast by a $1/_2$ grade and diffused the image for the entire print exposure using a piece of 6x6cm anti-Newton glass from a colour transparency mount (it fits neatly into an under-the-lens Multigrade filter mount). This filter increases exposure by a factor of 1.4 (a 10 second undiffused exposure becomes 14 seconds). I dodged the left of the rock during the initial higher contrast exposure. Undodged, it would leave too much weight on the left side of the print, which would require more burning-in of the water to the right, itself requiring more burning-in of the sky, and so on. Diffusion also softened the black border, included to balance the weight of the cliffs to the upper right and to provide contrast with the key area of water to the bottom left.

5. Print processing

Multigrade developer as usual, followed by an acetic acid stop and my normal two baths of Ilford Hypam fixer diluted 1+9. A brief wash was followed by a hypo-clear of 2% solution of sodium sulphite and then a one hour wash at 20C. The image was air-dried as usual, flattened in a heat press between two sheets of archival mountboard. I then applied white paper masking tape to the print margins, before applying a dilute blue dye solution to the dry print, using a swab of cotton wool. I first tested the dye on a reject print, making sure that it was not so strong that its manual application might look uneven. I gently dried the print with a hair drier, then removed the tape, before flattening the print again. After flattening, I retouched the print with the same dye solution. Why did I use a dye rather than a chemical toner? A chemical blue toner builds up contrast, possibly losing detail in the shadows. Conversely a dye is most noticeable in the highlights (where there is less developed silver) creating the subtle effect I wanted.

6. Print assessment

The print is almost as I visualised it in camera. However, maybe I should have darkened the sky a little more, using low contrast (subtle) filtration but would that make the moving water look relatively too bright? Perhaps so. In this case I think the more subtle approach is best. Contrary to popular belief, not all prints benefit from maximum contrast.

The Gribbin

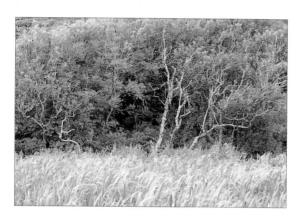 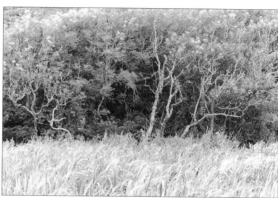

1. An unfiltered colour transparency of the scene, made just after exposure of the b&w image.
2. A straight-exposure proof print, i.e. with no dodging, burning-in or split-grading.
3. The final print, made on Ilford Multigrade matt, FB, split-graded and selenium-toned.

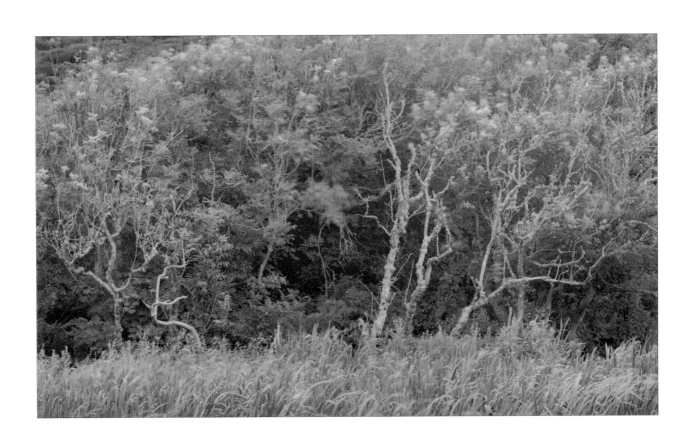

1. Image visualisation

Yet another almost monochromatic scene. Studied carefully, there is just a hint of cool blue-green in the shadows, just as one would expect. Thinking about how I would translate this scene into a b&w VC print, I saw two possible routes. First, I could raise the contrast of the scene through orange or red camera filtration, to pull out the shapes of the trees and darken the green foliage (especially the blue-green shadows). Secondly, I could opt for a more subtle approach: I could use green camera filtration to actually lighten the foliage, perhaps split-grading the print to put back some contrast into the shadows - but not so much as orange or red filtration. Had I photographed this scene in colour, undoubtedly I would have used a graduate filter to darken the foreground. It is much too bright.

2. Camerawork

Normally I take a small, leightweight set of aluminium steps with me, to get a higher camera viewpoint, especially for subjects like this. But, not this time. Being able to elevate the camera an extra foot or so would have made a great difference, by cutting down the amount of distracting foreground detail. Instead I realised I would have to print-in that part of the image at a lower contrast VC setting, both to darken it and to lower its contrast, thereby making it less distracting. The image was exposed late evening, in fading light: another reason why I didn't want to use a red filter - the shadows would have become completely without detail. Even with just a light green filter the film required a 1 second exposure, with red it would have required about 15 seconds and reciprocity failure (that increase negative contrast) would have lost all shadow detail. Once set-up, I waited for a breeze, believing that even a hint of movement would add extra life to the image. The lens was a 55mm micro, set at f.8.

3. Negative assessment

The best negative turned out to be one rated at ISO 200. It has just the right amount of shadow detail. Looking at the negative over a light-table, when it is viewed by transmitted light, it is not that easy to see any imbalance in the scene. But look at a print that is viewed by reflected light and such imbalances become all too obvious (note the dodging and burning-in work in the printing diagrams opposite). Had I used conventional b&w film, I might well have chosen a two-bath compensating developer that maximised the amount of shadow detail, whilst restricting the unwanted build-up of excessive density in the highlights.

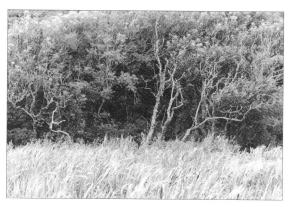

A contrastier version of this scene, made from the same negative as the picture on page 29 but printed harder. I prefer the main picture with all its subtle shades and delicate textures.

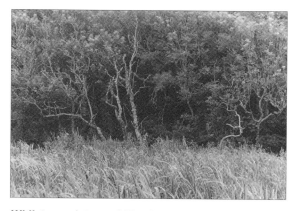

Whilst my picture of The Gribbin is primarily about tonality and texture, viewing the print in reverse clearly demonstrates just how important are the shapes of the trees and the overall compositon of the picture to its general success.

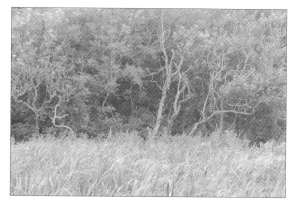

A straight exposure, low contrast print does not possess the subtlety of tone of the main, split-graded print on page 29. If using graded paper, I would flash the image to achieve something akin to the split-graded effect of the VC print.

Making part of the basic exposure at a grade 4 setting, to give better shadow separation, necessitated very careful dodging and burning-in of those areas to retain their tonal balance.

The second part of the main exposure was made at grade 1 to add detail and delicacy to the print highlights. Burning-in some of the brightest areas at grade 1 helped to tone them down.

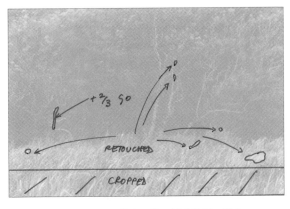

I burned-in some very distracting highlights. Using a very soft, low contrast grade 0 setting, there was little danger of any light overspill excessively darkening adjacent areas of the image. This overspill problem is all too common when working with graded papers.

4. Print exposure

This is not a difficult image to print, but to make a truly good print of it is quite hard. It requires careful balancing of the tonal values across the width of the image (in the shadows to both the left and right) and between those of the foreground and upper left. I didn't want the image to appear too symmetrical, but I certainly didn't want it to look like the straight exposure, reversed image opposite. I wanted to produce a print with a fairly limited tonal range, but not simply by printing on a soft grade. That would result in a very flat print, only suited to bleaching in Farmer's reducer - resulting in a higher contrast, highlighted approach that I didn't want. Instead I split-graded the basic exposure (pages 78-79), then burned-in parts of the image at a low contrast setting - to avoid the shadows going too black, as they would at a normal or harder contrast setting. I was careful not to burn-in the top left too much; keeping it reasonably bright retains some depth in the scene.

5. Print processing

I hardly varied my development routine for any of the images in this book, preferring instead to change print contrast through VC exposure control and altering image colour by toning or re-development. Here I used Multigrade developer as normal, followed by the the usual acid stopbath, Hypam fixer and sodium sulphite hypo-clearing bath. After a short wash of some fifteen minutes I toned the print in Kodak selenium toner, diluted 1+9. This archived the print and increased slightly the density of the darkest values - but without them blocking up. As for all toned work, I avoided touching the image area, in case of possible surface damage. This damage is most likely with selenium toner and the alkali variable-sepia toners that temporarily soften the emulsion before it dries. Washed for a further hour after toning, I drained the print as normal (without wiping it) and then air-dried it, emulsion side-up on a fibre-glass mesh screen. Some retouching was necessary, mainly to eliminate distracting highlights.

6. Print assessment

I'm pleased, the print doesn't look too photographic: there are no blacks and no whites - just greys. Making it this way reflects a greater awareness of how I feel about the landscape and a lesser dependence on safer, more conventional means of photographic 'expression'. For example, an obvious approach would be to sepia then blue tone the print to produce a green tone. It is a delicate, understated image. Toned that way, wouldn't we incorrectly see the colour before we saw the image?

Ramsay Sound

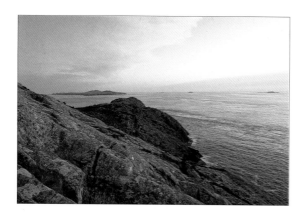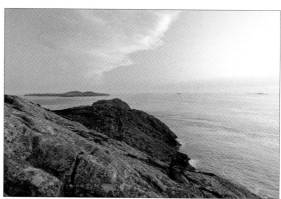

1. An unfiltered colour transparency of the scene, made just after the exposure of the b&w image.
2. A straight-exposure proof print, i.e. with no dodging, burning-in or split-grading.
3. The final print, made on Ilford Multigrade matt, FB, split-graded and thiocarbamide-toned.

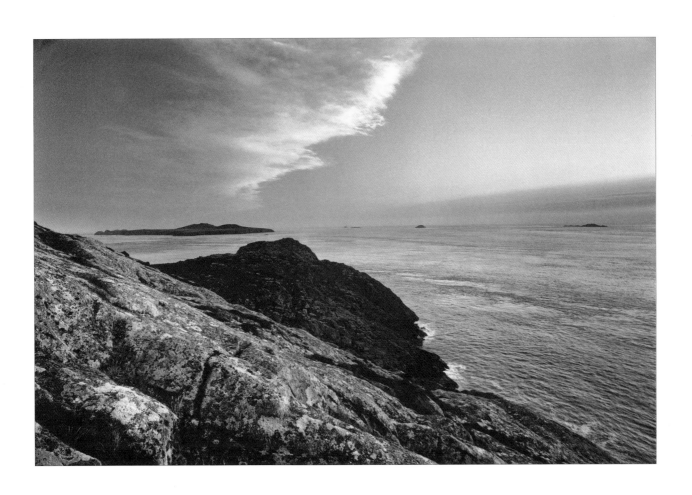

1. Image visualisation

Looking at this scene in colour, it would appear relatively easy to make in b&w. It isn't. Take away the colour contrast of the orange-clouds against the blue sky and in b&w we are left with two key areas of the image that have very similar tonal values of grey (just look at the print opposite to see what I mean). For maximum contrast, the obvious answer is to use both a polariser and an orange filter. But, for reasons explained in camerawork, below, that approach wouldn't work. In b&w, with subjects like this, we must ask ourselves if simply we wish to record the splendour of the scene (in which case we might use colour film) or if we wish to go one stage further. Using b&w means being able to see in b&w. For example, after we have photographed a scene like this and before we process our film, try to recall our view of it as we composed it. Is this view in colour or purely in b&w? For me, it is usually in b&w, which seems right except that looking at the colour transparencies of all the scenes in this book I have seen how much their colour values subconsciously affected and altered my b&w camera composition: a distraction which still needs working on.

2. Camerawork

I wanted to adopt a low viewpoint, using a wide-angle lens to to capture enough foreground and all of the cloud to balance the composition of this image. However, using a 20mm lens, I had a filtration problem. Using a polariser the cloud would be rendered more visible, but it would also exaggerate the brightness of the lightsource to the right by darkening the left side of the view which is at rightangles to the lightsource (the angle at which a polariser works best). An orange filter, would not create this effect but neither would it render the shape of the cloud quite so well. Using both filters together is a problem with my 20mm lens, since I get vignetting. In the end I opted for just the polariser combining its use with split-grading of the VC print - also using a lower contrast filter to burn-in the right side, so that it would not compete in brightness or contrast with the main cloud. I photographed this image at sunset, focusing on a point about $1/3$ of the way into the scene.

3. Negative assessment

Another XP2 negative rated at ISO 200. The extra stop of exposure has given plenty of shadow detail in the lower left foreground to dodge and then locally bleach it with Farmer's reducer. Being a stop over, the XP2 neg is also finer grained - useful considering the featureless expanse of monotone sky.

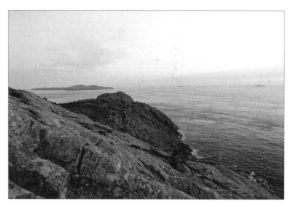

Notice how the cloud has all but disappeared in this unpolarised version of the scene. Even the use of a more conventional orange camera filter would not have rendered it as clearly visible. Split-grading would help.

An alternative, less striking view of the scene, made some ten minutes earlier than the main picture on page 33, whilst waiting to see how the cloud might change in shape. Exposing extra images, such as this, performs a useful learning role.

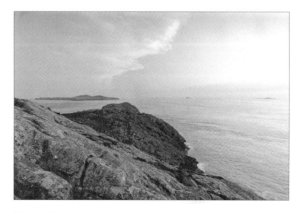

Poor alignment of the negative in the enlarger (allowing too much of the clear film rebate to remain visible), has allowed light passing through the negative sprocket holes to locally fog the print. Intense light such as this can also bounce off the easel blades, to similar effect.

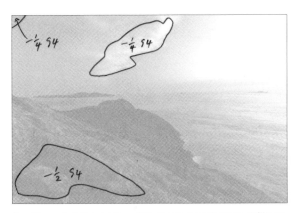

I split-graded the print, using grade 4 and grade 1 filters, dividing the exposure time equally between the two. I dodged the main cloud a little prior to burning-in the whole sky.

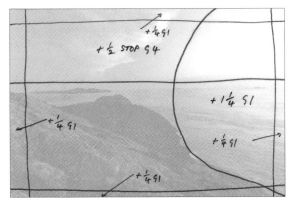

I burned in the sky from the horizon line upwards, using a piece of card to mask the lower part of the print and moved the card gradually up and down to grade-in the extra exposure.

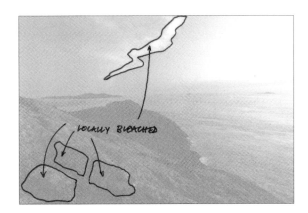

Locally bleaching the cloud and foreground has added extra contrast more easily than by dodging and burning in those areas at a higher contrast filter setting. Besides local bleaching work can be more precisely controlled.

4. Print exposure

I chose to dodge then bleach the lower left foreground. Working with VC, I could have dodged it for almost all the basic exposure and then burned it in for about half that time at a higher contrast setting. This would have raised the overall contrast of the area, but the advantage of using bleaching is that we can see the effect it is having, whilst we can only see the results of dodging and burning after the event, i.e. post development. As is my usual practice, I made various test-strips at different exposure and contrast settings that covered the lower left area, the main cloud and the cloud bank to the right, to give me the exposure information I needed to make a printing plan for this image. I tested the Farmer's reducer on a couple of these to see how the main cloud might look if it was bleached. I realised that it considerably improved the image - provided the print was about $1/3$ stop too dark in that area prior to bleaching (bleaching highlights that are too bright can leave them distractingly bright).

5. Print processing

After my usual processing routine, I briefly washed the print and, prior to hypo-clearing, I laid it on a flat sheet of plastic and carefully wiped off most of the excess moisture using a soft rubber wiper blade. Then I applied the Farmer's reducer with a swab of cotton wool, gently working it over the main cloud and lower foreground, occasionally rinsing the print in cold water to arrest the process and to check its progress, repeating the wiping and bleaching process until the desired effect was achieved. It is important not to overdo the bleaching, since its contrast increasing effect also accentuates the graininess of the area. Too much bleaching can also change print image colour to a warm brown - not the result of staining, but simply a change in the physical structure of the bleach-affected silver. After the Farmer's, I washed the print, then hypo-cleared it, and washed it for an hour prior to toning. I bleached the print in the sepia toner bleach until the highlights had gone, but arrested this process before the blacks appeared to lose too much density. I toned the image in the warmest dilution of thiocarbamide.

6. Print assessment

In retrospect I think I may have overdone the toning bleach, since it has resulted in too much colour in the mid-tones and shadows. Over-toning the image in the warm dilutions of thiocarbamide sepia tends to reduce image contrast, undoing much of the camera filtration, print exposure and Farmer's work.

Wreck - 1

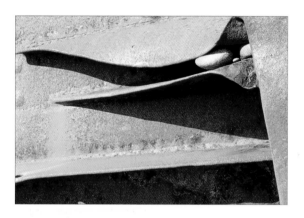

1. An unfiltered colour transparency of the scene, made just after the exposure of the b&w image.

2. A straight-exposure proof print, i.e. with no dodging, burning-in or split-grading.

3. The final print, made on Ilford Multigrade matt, FB, split-graded and thiocarbamide-toned.

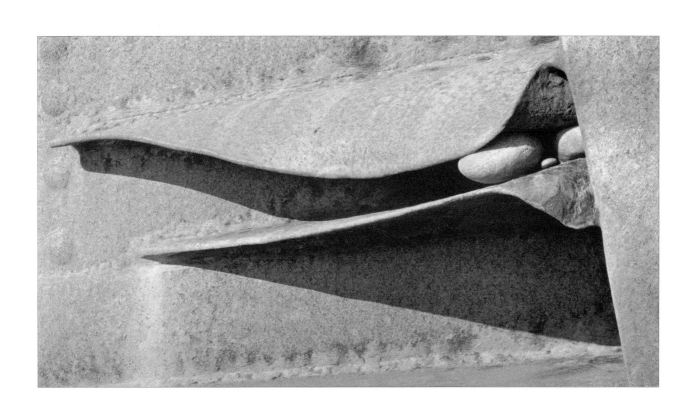

1. Image visualisation

Looking through the colour transparencies in this book it is interesting to note how many of them are quite monochromatic. This image is no exception, although the small yellow flow-line, from rusty water, does play an important role in the composition of the colour transparency. Take away this colour and in b&w we have to look for other qualities within the scene. In this case, the greater exposure latitude of b&w negative film over colour transparency material means that it is possible to include shadow detail in the b&w print that is lost to the colour image. The b&w photo relies heavily on this detail for its success; without it the image looks dissappointingly two-dimensional, being purely graphic in nature. As a matter of course, I tried viewing this subject with a polariser. Although it enhanced the colour of the subject, it also took away much of the specular, textured quality of the metal upon which the b&w version relies.

2. Camerawork

I settled upon two possible compositions for this image, not being exactly sure of how much I should allow the shadows to fill the frame. I made exposures of both of these, aware that, as in the past, it is often best to evaluate their differences at leisure, by looking at contacts or proof prints of them. Looking at these images I notice much of what might be at fault with my composition that I had otherwise overlooked in camera. For this reason (as a learning exercise) it is a good idea to bracket our exposures and to make images from alternative viewpoints, or of slightly different compositions. I made this image with a 55mm micro lens, set at f.11, using no camera filter. The image was made at mid-day, giving shape to the shadows, but the almost front-on nature of this light meant that some of the texture of the subject was lost. Perhaps this doesn't matter. If it does, there is always the option of lightly bleaching the entire print in Farmer's reducer.

3. Negative assessment

I bracketed my exposures of this composition, settling upon one with the most shadow detail. This seems to be a recurrent approach, indicating my preference for prints that have good shadow detail. Imagine this image if it was made from a normally exposed negative with less shadow detail. Would it work so well? I think not. Because of the extreme brightness range of the scene, had I used normal b&w film I would have down-rated it by a stop (ISO 400 to ISO 200) and shortened development by 20%, or used a two-bath compensating developer.

Coming in closer to the subject has produced a tighter crop, that usefully eliminates the diagonal shadow at the bottom of the subject. It also loses the end of the uppermost shadow which is integral to the main picture.

A similar subject but in no way a comparable image. It is not so much the lack of directional lighting which is at fault, rather it is poor camera compostion. Try cropping a third off the left or the right side of this image - it looks very much better.

This is another good example of a picture that maybe doesn't work when viewed in reverse (a techniques we can use in the darkroom to check for print imbalance). It usefully provides a fresh impression of the scene, which can often improve our approach to printing the subject.

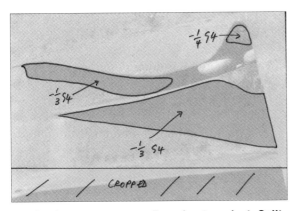

The basic exposure was all made at grade 4. Split-grading this image would have lost some of the highlight texture.

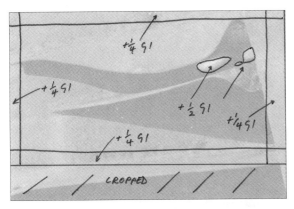

Burning-in at grade 1 has added detail but without too much contrast. Burning-in the sides at grade 1 helps focus the eye on the contrastier central section.

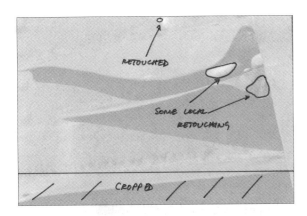

Retouching this print with a very fine 0000 artist's brush, using watercolour pigments, I was able to remove much unwanted, fine specular detail in the pebbles. This would not have been possible by just burning-in.

4. Print exposure

Conventional b&w photographic books teach us to print with a graded paper whose printing range matches the density range of the negative. Working with smaller format 35mm negatives we need all the help we can get, to give the highly magnified image a sense of luminosity, so this straight-print exposure approach tends not to work too well. Using VC paper is a much better option. In this case, I used a contrast setting about one grade harder than 'normal', exposing the print for the lower mid-tones, dodging the shadows and then burning-in the brightest highlights (the pebbles) with a lower contrast filter setting. Cropping the bottom of the print, leaving out the diagonal line of shadow, helps to concentrate the eye on the more natural shapes that are the focus of this image. If I were printing this image on graded paper, I might locally flash the pebbles, to help pull in the detail, since just burning them in at the same contrast setting would make them look rather contrasty, lacking delicacy.

5. Print processing

Ilford Multigrade is a neutral-toned paper. For this print I wanted a very slightly warm image tone, so why not use another make of paper? Quite simply, we can emulate the colour of other papers through subtle toning or re-development techniques. Here I decided to thiocarbamide (sepia) tone the print very lightly, putting just the merest hint of colour into the print highlights. This technique can be used with proprietary toning kits or those made up from our own formulary. The technique involves a brief immmersion in the sepia toner bleach - the duration of which is best judged by having an identical reference print (or test-strip) to hand, for comparison. Once bleached, the print is washed and then toned according to the toner's instructions regarding the desired image colour. After toning in the very warmest (weakest) dilutions, some loss of image density may occur. This may be due to an overworked toner, or too much residual fixer in the print, or the toner may be too cold. In the latter case, immersing the toned print in a dish of warm water (at about 30C) usually helps to restore image density.

6. Print assessment

Trying to visualise the <u>matt</u> surface print prior to camera exposure, I was conscious of the importance of retaining the shadow detail. This was lost in the colour transparency (due to the more limited exposure latitude of the film) but retained in the b&w image by downrating the film and dodging the print. In b&w, we always expose the film for the shadows.

Wreck - 2

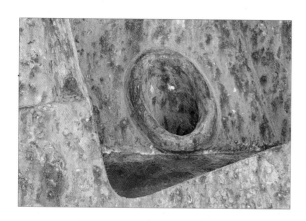 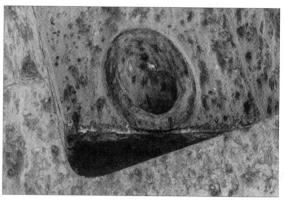

1. An unfiltered colour transparency of the scene, made just after exposure of the b&w image.

2. A straight-exposure proof print, i.e. with no dodging, burning-in or split-grading.

3. The final print, made on Ilford Multigrade fb, split-graded and thiocarbamide-toned.

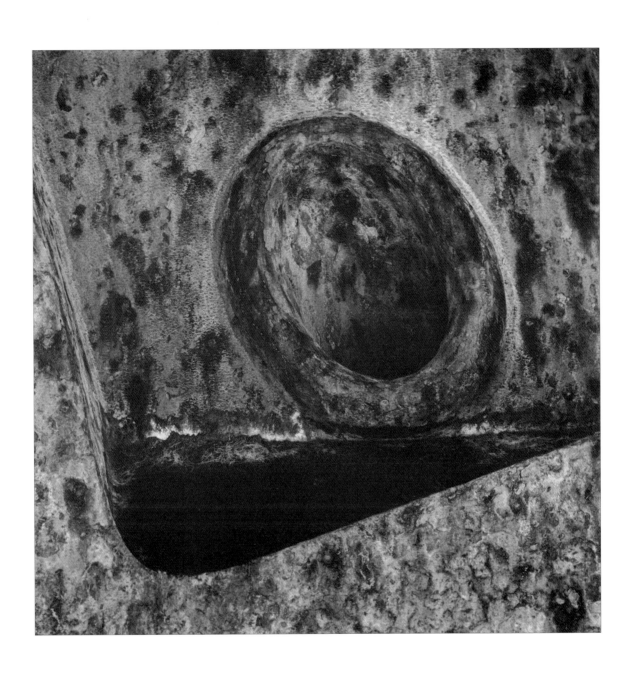

1. Image visualisation

It is hard not to be attracted to the extraordinary richness of colour of the transparency of this image. Imagine how those colours would have looked if I had polarised the image as well - both the rust-orange and the algae-green would have become even more saturated. So why bother with a b&w image? Doesn't the colour photograph say it all? Yes, but then maybe that is the problem, perhaps it says too much. Working in b&w, and now with the creative control of VC papers, we have the potential to be even more selective with our work. Here I was interested in depicting just the textures and shapes of this ruined hull, abstracting them to the point where they almost ceased to look photographic (i.e. lacking the obvious realism of the colour image).

2. Camerawork

I always find it hard composing square images with the rectangular format of the 35mm camera: somehow I always try to fill the frame, it's habit I guess. Perhaps it's just personal preference, but I find this type of more abstract image, or still life, usually works best square: it allows the eye to wander freely around the image without being pulled one way or another as in Wreck - 1, or like the picture of Ramsay Sound. Having composed the image in camera, I decided on a high contrast approach. To this end I considered what filter, if any, I should use. I reckoned a polariser would make the water too dark, whilst an orange or green filter would not enhance the contrast of the rusted metal or algae respectively. In the end, I made various exposures with and without filters, thinking that I might over-expose and then bleach back the print, to get the textured effect I was after. The lens was a 55mm micro, set at f.11. The image was exposed at around mid-day, with the sun directly behind the subject. Just to be safe, I flagged the lens, holding my hand in the path of the sun, to eliminate any possible flare.

3. Negative assessment

I chose an unfiltered negative. It seemed to have the best balance of density between the body of water and the textured metal. Other negatives, that I had filtered in camera, didn't quite make it, as some small $6^1/_2$ x $8^1/_2$" proof prints showed. (It's not that often that I make a print from an unfiltered negative.) Studying the negative and the contact, it seemed like a straight exposure print might be possible. But, enlarging a negative and then bleaching back the print, as I intended, always combine to 'open up' an image exaggerating any slight imbalance, therefore requiring dodging and burning-in.

Another porthole, but this time part of a less abstract landscape. This picture is cluttered. Tighter cropping and light on the wreck (rather than just to the right) would help. A re-shoot would be much better than trying to salvage this negative through split-grading techniques.

This is part of the same wreck. In colour it looks wonderful, with blue shadows and bright rust-coloured metal. But in b&w it is a disaster. It lacks interest and the lighting does nothing to enhance the image.

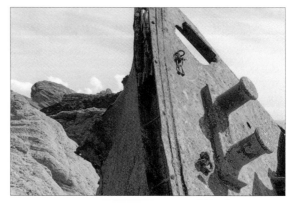

Another wreck and another picture that doesn't quite make it. Even VC techniques won't help much. Why not? For a start the composition is no good. The picture is tightly cropped to the right, but not to the left. Likewise it is neither a landscape nor an abstract image.

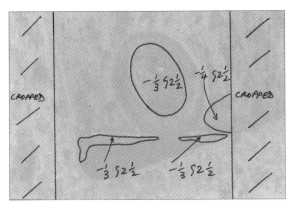

I dodged four parts of this print. This required dodging two areas at once, since the total dodging time for all four, if worked on separately, exceeds the basic exposure time.

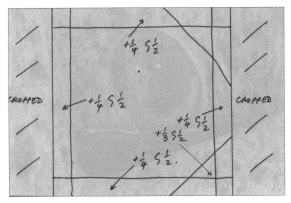

I was sure to burn-in the sides, aware that bleaching-back the picture always lightens these parts of the image first, making them look too light. I used a lower contrast setting to subtly darken them.

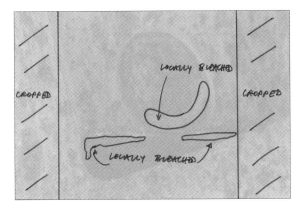

Even though I bleached the entire image I still locally bleached it first to enhance three key areas. As we can see from the diagrams, two of these areas were dodged as well. This really does require a well-detailed negative if we want to avoid losing contrast and density.

4. Print exposure

If enlarging and then bleaching-back a print combine to show up any imbalance in the image, then viewing the picture upside down, or back to front (in a handheld mirror), does wonders for exposing its compositional strengths and weaknesses. I view all my prints this way. It teaches me so much about image balance, clearly pointing the finger at any areas that are either too dark or too light, or perhaps too contrasty or too flat. We can dodge or burn these areas, also changing grades with VC paper to locally modify their contrast. Good photography relies so heavily on being able to read a print, knowing where and how to modify its exposure for maximum effect. For this print I made a few test-strips at various exposure and contrast settings, including some that were over-exposed by a stop or two. The latter I wanted to use as tests for bleaching back. I got the best result with a test-strip overexpsed by $1^1/_2$ stops, made about a half grade too soft. Prior to bleaching, it looked much too dark, but viewing it by transmitted light showed a wealth of detail waiting to be revealed by bleaching. Farmer's is excellent for raising the micro contrast of an image, i.e. accentuating fine textured detail.

5. Print processing

I processed the print normally, then washed it briefly prior to bleaching in Farmer's reducer. The extra $1^1/_2$ stops of exposure prevented the highlights from bleaching to base white. Instead they turn a warm brown as the structure of the silver image is changed. When bleaching a whole print in Farmer's, it is important not to agitate the dish too much or else the sides will reduced first, since solution activity is greatest where there is the most turbulence, i.e. at the edges of the agitated dish. When using Farmer's, I always combine the bleach with the fixer in the same dish. They can be used separately but the print lightens further when fixed separately. After bleaching, I washed the print and then hypo-cleared it in a 2% solution of sodium sulphite. A one hour wash was followed by Tetenal's gold toner. This turned the warm brown-black image to a red-orange. Then I washed the print for an hour prior to drying.

6. Print assessment

The print hardly looks photographic. It looks more like an etching. Photography is overly concerned with making its images look recogniseably photographic. Is this necessarily an ingredient for success? I think not. Good image making requires an understanding of the rules and knowing when to break them for best effect.

Pontfaen

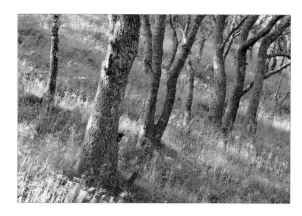 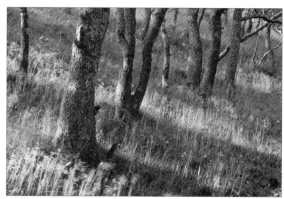

1. An unfiltered colour transparency of the scene, made just after the exposure of the b&w image.

2. A straight-exposure proof print, i.e. with no dodging, burning-in or split-grading.

3. The final print, made on Ilford Multigrade matt, FB, split-graded and very slightly blue-toned.

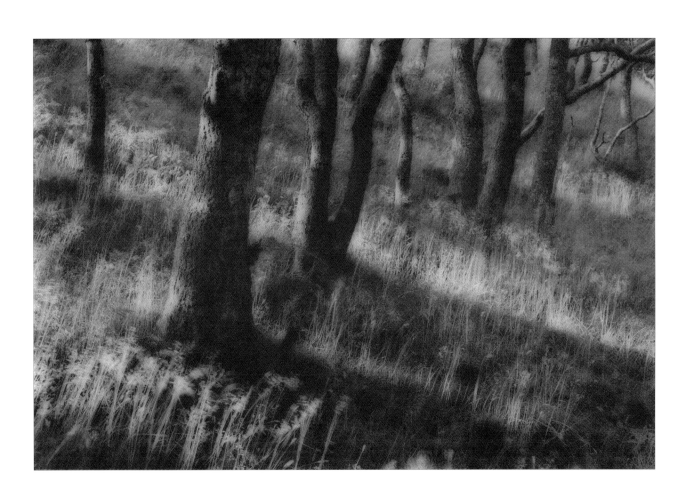

1. Image visualisation

To date, I have made most of my images in Britain. Perhaps it is the often dreary quality of light and the usual lack of colour that is so appealing, afterall it makes everything so monochromatic, simplifying the process of seeing in b&w. Also it allows me to combine the creative potential of both camera <u>and</u> darkroom techniques. Were conditions always too good, I think my work would rely more on the inherent qualities of the subject and less on my own abilities of interpretation. Instead, the darkroom, and now VC paper, provides us with a wonderful opportunity to make our own mark on a scene, especially through our printing of it. For example, although the lighting of this scene makes the image, it doesn't complete the picture. Knowing what was possible with VC paper - prior to composing this picture - made it possible.

2. Camerawork

The colour transparecny of this scene speaks most of 'light'. This is often the case with colour transparency work, since we expose the film for the highlights. In b&w we expose for the shadows. This allows a quite different interpretation of scenes such as this. Here my b&w image concentrates on the shadowed shapes of the tree trunks - the result of a combination of camerawork and printing. The composition of the image relies on the angled quality of light, the result of waiting for a couple of hours for the sun to settle. Anticipating the light is an important aspect of all b&w camerawork. Before trying to make any images, I prefer to get to know a location, visiting it several times, working out various possible viewpoints, before returning when I feel the light is right. Unfortunately, this requires the freedom to come and go as one pleases - a rare luxury for <u>all</u> of us. Still, it makes the point, that if you don't have much time for your camerawork, don't be disappointed if you can't produce masterpieces. Photography is all about 'taking' time. This is another image made on the 55mm lens, set at f.11.

3. Negative assessment

Looking through several negatives, one that was made with an ND filter, to slow the shutter speed to $1/4$ second had just the right amount of movement in the foreground grasses to contrast nicely with the strong, static shapes of the trees. Had there been no wind, I might have diffused the image in camera, for a similar effect, by locally applying a small amount of grease to a glass filter. Like the other negatives in this book, this was exposed for the shadows. I see good shadow detail as a must for my b&w work.

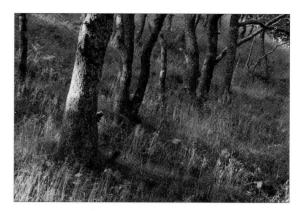

Exposed just 5 minutes after the main picture on page 45, the light is well past its best. Arriving at a subject with time to anticipate the light really does pay-off, saving hours of often wasted time in the darkroom.

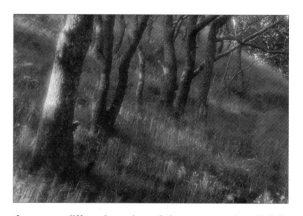

A camera-diffused version of the scene and a slightly different composition. Had there been more going on at the top right, to balance the view, this image might have worked. Dodging the top right could help - a little.

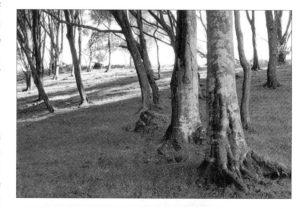

Not "one for the bin", but more of a useful reminder of how some scenes don't translate into b&w. The moss-covered trees are lost to the strong back-lighting, whilst a perspective control lens has lost the slope of the hill. Try viewing this picture in reverse; it looks much better.

Diffusing the print, rather than in camera, can block up the darkest areas of the print where the diffusion effect is greatest. Hence I dodged the darkest shadow areas to retain detail there.

Burning-in the bottom left at the grade 4 setting (rather than the softer grade 0 used below) has kept the highlighted grasses looking bright and luminous.

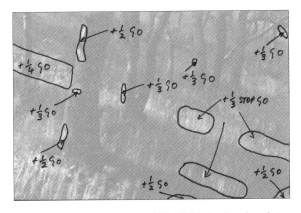

I darkened various unwanted highlights by burning them in at grade 0. This I did with the diffuser still in place under the enlarger lens. Flashing this print (to tone down these details) would not work well when combined with the light spillage effect of enlarger diffusion.

4. Print exposure

There is too much going on in the undiffused version of this scene, that competes for attention: finely textured detail is too prominent - in my image I wanted the trees to dominate. Diffusing the print helped to solve most of this problem. What unwanted bright detail then remained visible I burned-in at a grade $1/2$ contrast setting, using the technique to play down those areas by reducing their contrast whilst gently building up their density. What was difficult to assess with this print was how much I needed to darken the bottom left. Whilst I wanted the grasses to be luminous, I didn't want them so bright that they would lead the eye out of the picture. In these situations, it is easy to settle on a compromise when, very often, being bold is best. But how do we decide what looks best? A useful way of learning is to study some photographs we really admire, trying to visualise how they might have looked as mere proof prints. (Don't even begin to imagine that such wonderful images were straight exposure prints.) Try not to work out just how the photographer made the image but why - then how.

5. Print processing

Diffusing a print distorts the tonal range of the image. If overdone, the highlights block up and look veiled. Resin coated prints are quickly washed and easily dried, for rapid assessment of such techniques. If the print looks too dark another can quickly be made. It is harder working with FB prints. So, as a viewing aid, I rapidly dry a briefly washed test-strip, using a heated flat-bed drier (kept solely for that purpose). Once dry, the test-strip can be assessed for density and contrast. FB papers dry-down so much, especially enlarger-diffused prints, that anything up to a 20% reduction in print exposure might be necessary (including a reduction of all burning-in exposures). Matt surface papers are the hardest to assess, since shadow detail that is visible in the wet, glossy looking print often disappears. So, do we print the image lower contrast? Or do we dodge the shadows, or do we reduce the basic exposure time and then burn-in the highlights?

6. Print assessment

I left the foreground grasses deliberately bright. In the print of The Gribbin I darkened them. Here they balance the heavy weight of the trees. In The Gribbin they compete with them until darkened. The Gribbin is a quieter, softly lit, contemplative picture. This image is about the contrast of shapes and forms, rendered visible by the direct quality of the sunlight and an uncompromising approach to printing.

Cradle Bay

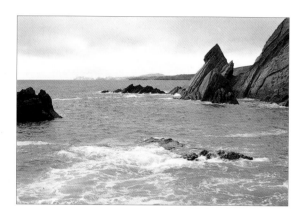 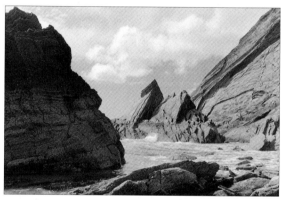

1. An unfiltered colour transparency of the scene, made just after the exposure of the b&w image.

2. A straight-exposure proof print, i.e. with no dodging, burning-in or split-grading.

3. The final print, made on Ilford Multigrade matt, fb, split-graded and thiocarbamide-toned.

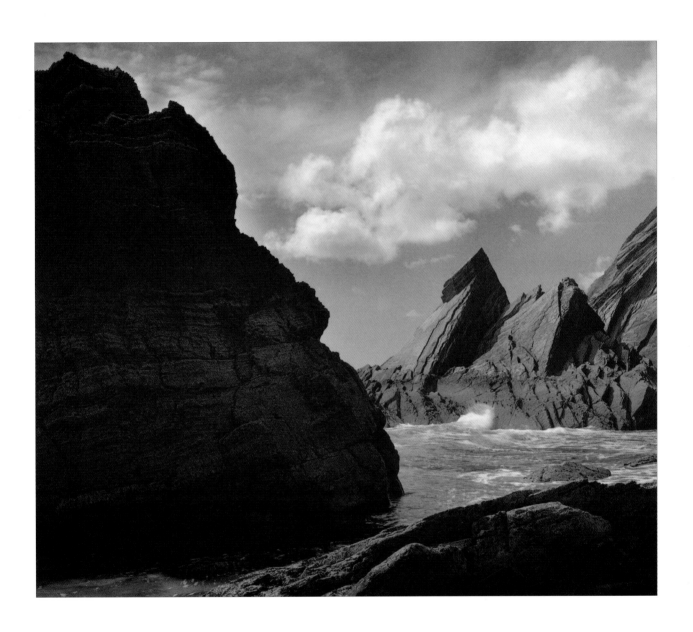

1. Image visualisation

I visited this scene several times before I made this image, from this particular viewpoint. As you will see from the other prints of these rocks, elsewhere in the book, there are countless ways of interpreting a scene depending upon viewpoint and the quality of light. Having the variable contrast control of VC paper, we can then play upon these, in particular upon the way the quality of light adds dimension to an image. Here the quality of light sculpts the rocks. However my decision when to expose the image was also based on the knowledge of what I could do to the clouds, by way of split-grading the VC print. In particular I wanted to give them more shape than they possessed in the mid-day light. Good b&w camerawork always involves thinking about the darkroom prior to film exposure, by visualising how we want the print to look and knowing how best to achieve it. If we can't visualise the finished image clearly, we are leaving too much to chance. Such images then rely, often heavily, upon the corrective, rather than the creative potential of VC paper.

2. Camerawork

Polarising this scene helped to lift the clouds but darkened the sunlit face of the main rock. Using an orange filter therefore seemed like the best compromise, especially if the sky could be printed-in about a $^1/_3$ of a stop too dark, at a softer grade setting and then lightly bleached with Farmer's. This begs the question, how do we filter an image in camera if we don't know the full potential of the darkroom? Besides, trying to do all the work in-camera doesn't necessarily produce the best results, but doing as much as possible in camera does help. Having composed the image, I waited for a combination of the right cloud pattern and a wave to hit the rock. I also made various other exposures with different cloud patterns, none of which worked as well as this. Good composition means being able to anticipate likely changes in the weather, and being prepared to wait for them. Previous visits told me that mid-day gave the best angle of light for the main rock, it was then a case of turning up on a day when the tide was out. The image was made with a 35mm lens, focused on the edge of the lefthand rock, with the lens set at f.11.

3. Negative assessment

The weathered upper half of the left-hand rock is so black, that I felt it was imperative to downrate the film to ISO 200 to introduce more detail into it. This has prevented it from looking unnaturally dark - as if it had been clumsily burned-in.

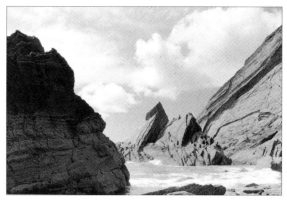

A slightly different camera composition, to include more of the clouds, has lost much needed detail at the bottom of the picture that gives the main picture a much greater sense of depth. This version is very top-heavy.

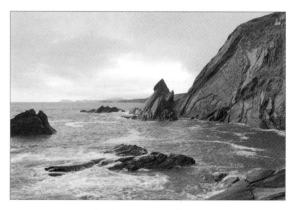

Another viewpoint of Cradle Bay. Here the light is good and could be improved further by burning-in the sky a little more at a harder contrast setting. However the water is too detailed and fussy, detracting from the more pleasing rock striations.

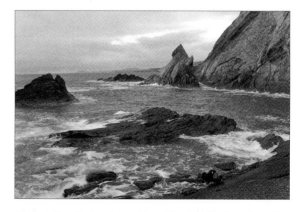

This picture is too busy. Touching the horizon-line, the large rock to the left does not state its place in the image. Also the landmass to the top right needs burning-in, whilst the foreground is a jumbled mess of rocks and half-frozen water. A straight horizon might also help.

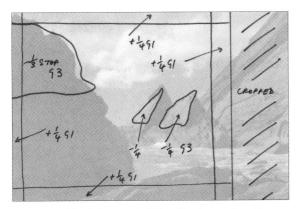

Although I had downrated the film by a stop, it was necessary to dodge the still very dark upper section of the rock to the top left. The print was made at grade 3.

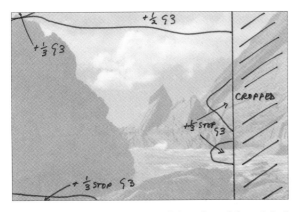

I burned-in several areas around the edge of the print at the same grade 3 setting. This was to prevent the eye being lead out from the centre of the picture, rather than into it as I had intended.

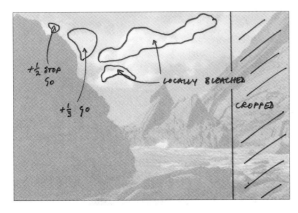

Two bright highlights, adjacent to the dark mass of rock (which made them look relatively brighter), benefitted from some extra grade 0 burning-in. This prevented them from clashing with the main cloud formation which I locally bleached for added effect.

4. Print exposure

Enlarging a negative opens up the tonal values of the image, making it appear lower in contrast, so that the bigger the print the higher the contrast setting required. Therefore, enlargement also tends to change the balance of the picture. The result is that for a picture like this (which looks good as a small straight-exposure contact print), we can expect to carry out much dodging and burning-in, plus some local bleaching in this case. This is where VC paper really comes into their own. Striving for that 'perfect' negative, which gives a straight exposure print, might be a good discipline but it does ignore much of the creative potential of VC papers, as discussed in the introduction. Looking at the printing diagrams opposite, it is clear to see which areas of the picture I worked on. Deciding what to dodge and what to burn-in takes practice, but by trying to visualise how we would like the finished print to look, the process can be made a lot simpler, i.e. identify the goal and the path to it becomes clear(er). To this end, do not be afraid of using paper to experiment with different print exposure combinations. Only by making prints can we actually see what looks right and what doesn't.

5. Print processing

After processing as normal (Multigrade developer 1+9, for 3 minutes, followed by an acid stop and Hypam fixer) I briefly washed the print and then set to work with a dilute solution of Farmer's. I applied it locally with a swab of cotton wool, gently working it over the clouds which I had deliberatley burned-in about 1/3 of a stop too dark. As usual, I intermittently rinsed the print with cold water, to arrest the bleach and to check its progress. After bleaching, I rinsed the print, then hypo-cleared it and then washed it for an hour prior to thiocarbamide toning. I used the coldest tone (most alkali) dilution to give the purple-brown colour to the image highlights. Once toned, I washed the print for another hour and air-dried it as usual.

6. Print assessment

Cropping this image has helped. The moment I looked at the contact I knew I didn't want all the detail to the right of the main rock. Besides, the uncropped version places the main rock rather too obviously dead-centre, where it holds the eye, rather than allowing it to move around the image. I've heard so many photographers procalim that they always print full-frame. Is everything we see rectangular? Here I composed the image badly in camera. What comes first: pride or print?

Solva Bay

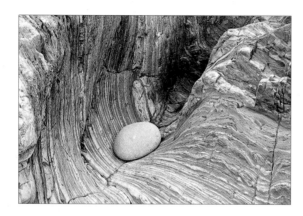 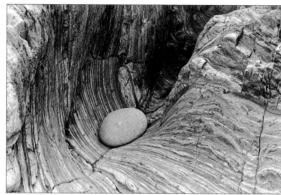

1. An unfiltered colour transparency of the scene, made just after the exposure of the b&w image.
2. A straight-exposure proof print, i.e. with no dodging, burning-in or split-grading.
3. The final print, made on Ilford Multigrade matt, FB, split-graded and gelatin dye-toned.

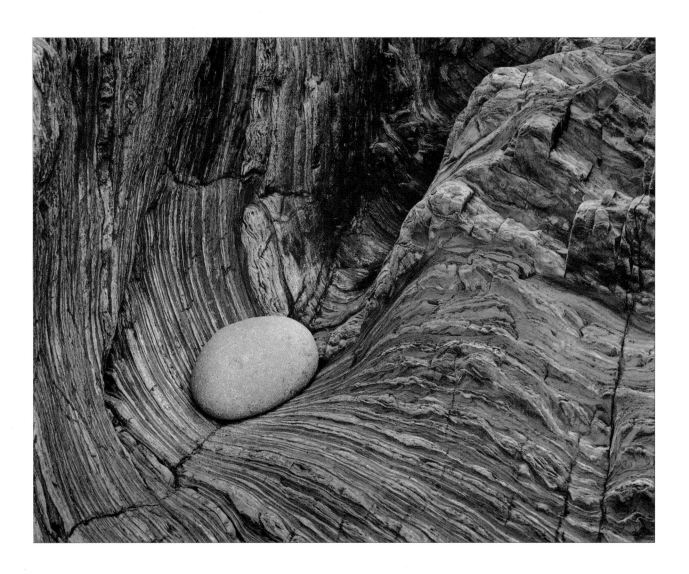

1. Image visualisation

In Wreck - 1 the movement within the print comes from the shadows. By way of a contrast, and to illustrate some alternative techniques, I wanted to produce an image where it came from the highlights - in this case from the thin lines of light rock that pass across the image. Wreck - 1 relies heavily upon the directional, transient nature of the shadows; in contrast Solva Bay does best without directional light. Imagine how cluttered this scene would look were it illuminated by bright sunlight - any shadows would interrupt the flow of the picture. Images like this appear simple to make, yet to succeed they need to be well seen, with much attention paid to the elimination of otherwise distracting details. Without any obvious drama to catch the eye, they also need to be carefully balanced in printing, which, for this image, would mean plenty of burning-in at a lower, grade 1, contrast reducing setting. Working with VC paper makes possible this type of considered approach.

2. Camerawork

I tried to visualise this scene printed on VC paper, using local contrast control to balance the image, with the print perhaps bleached to highlight the natural texture and pleasing flow of the rocks. Slowly the image came together. Composing it, I was conscious of the need for tight cropping. This type of subject often looks good to the eye when viewed in three dimensions, and often looks good in camera, but in print the focal point of the image is often lost to a hitherto unnoticed mass of distracting background detail. I chose a 55mm lens, having first considered a closer viewpoint with something slightly wider-angle, as a means of enhancing the lines sweeping in from the right, but considered that approach a little too obvious. Instead I decided that bleaching the image and then dye-toning it would emphasise the lines much better. In contrast to chemical toners, which only work on the silver image, dye toners show up most in the brightest parts of the image where there is more base-white showing through. I made this image without camera filtration, focusing the lens just in front of the pebble. F.16 gave enough depth of field to put the whole image into focus.

3. Negative assessment

Looking at various bracketed negatives of this scene, I chose the one with the most shadow detail, since I was conscious of the need to avoid the shaded area above the pebble from blocking up. This more detailed negative allowed plenty of dodging of that area.

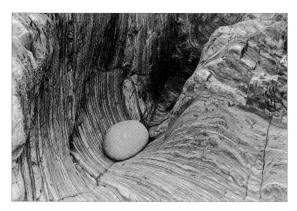

The same camera viewpoint as the main picture on page 53, but the pebble is in a slightly different position. Here it sits too much above the fissure-line upon which it rests, throwing the picture out of balance.

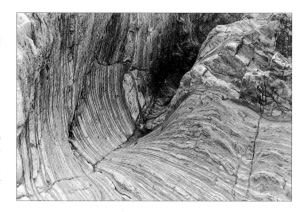

Take the pebble away and what do we have? To make this version work, I would use the area of deepest shadow as a focal point, burning-in the left side, then the bottom and upper right of the print to balance the image.

A very similar subject but my treatment of it is far from the mark. I would crop 20% off the left side, then burn-in the bottom right corner, grading-in the exposure about a third of the way into the print. At present there is too much overall contrast and not enough local contrast.

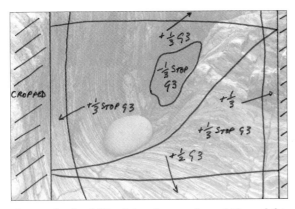

The emphasis of this picture is upon the pebble and the way it sits in the weathered rock formation. Dodging the dark central shadow prevents that area from being the focus of attention. The print was made at grade 3.

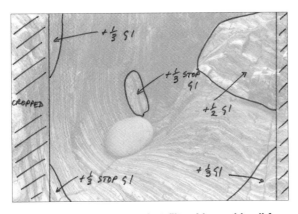

Using a lower contrast grade 1 filter, I burned in all four corners of the print and an area between the rock and the darkest shadow. Without this extra exposure the eye is less easily led along the rock lines.

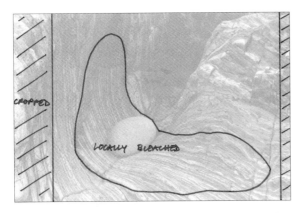

Some local bleaching has helped to pick out the striations. I carried out this work, as always, with an unbleached reference print to hand. Without such a print it is very difficult to judge how far the print has been bleached, if at all.

4. Print exposure

Despite the apparent evenness of illumination, this print was quite hard to balance since the foreground faced upwards, towards the light. Simply burning-in that area wouldn't be enough to balance the picture because the top right also looked quite contrasty, containing some eye-catchingly bright highlight detail. Printing-in all these areas at the same contrast setting, as with graded paper, would not work too well. For a start burning-in the bright highlights would cause the adjacent shadow areas to darken excessively, thereby drawing attention away from the main subject. In effect, this is a print I would only want to tackle with VC paper. It requires a delicate, balanced touch and very often graded paper can't provide that sort of control. To facilitate the bleaching of this image, I made the print a little too dark, about $1/3$ stop too dark in fact, and about a $1/2$ grade lower in contrast. Using a lower contrast setting kept open the shadow detail.

5. Print processing

Processed as normal, I washed, hypo-cleared and then washed the print for an hour (remember, if the water temperature is lower the washing time needs to be increased). After washing, I air-dried the image, being sure not to touch the surface (as always) since I didn't want any greasy fingerprints, or the like, to interfere with the application of the dye solution used to tone this print. Once dry, I carefully flattened the print between two clean pieces of archival mountboard and then applied white paper masking tape to the print margins, so that they would remain untoned. Just as for the prints of St. Non's Bay, I applied the solution with a swab of cotton wool, lightly wetted with solution. Similarly I first tested this solution on a reject print of about the same density, applying it gradually, very dilute, layer by layer. Quickly drying off the test print with a hair drier provided an instant evaluation of image tone. A textured print like this is much easier to colour than one like St. Non's that contains monotone areas that reveal even the slightest misapplication of the dye solution. Once dry, I gently flattened the print again and then I spotted it, toning down many small specular highlights that were too small to burn in.

6. Print assessment

Looking through the viewfinder it was hard not to be taken in by the subtle range of natural colours in this scene. I felt that even an unfiltered, straight exposure transparency would look good, but realised that a b&w print might not unless the 'flow' of the rocks was drawn out by bleaching and toning.

St. David's Head

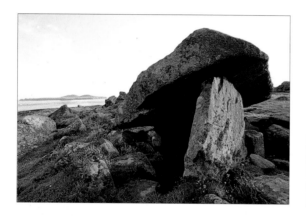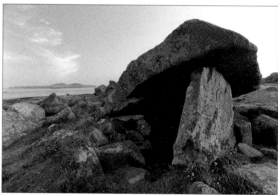

1. An unfiltered colour transparency of the scene, made just after the exposure of the b&w image.
2. A straight-exposure proof print, i.e. with no dodging, burning-in or split-grading.
3. The final print, made on Ilford Multigrade matt, FB, split-graded and thiocarbamide-toned.

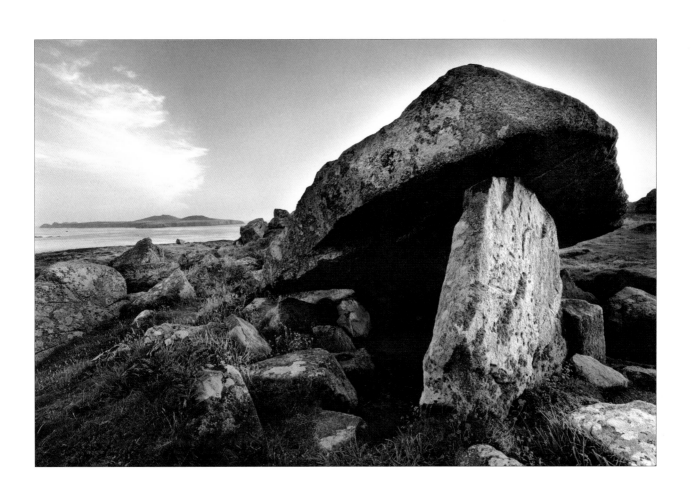

1. Image visualisation

Immediately obvious subjects, such as this, are much easier to photograph: it is simpler to photograph other peoples' creations rather than make our own images purely from scratch. That said, to make a truly memorable image of such a place is much harder, since we have all seen photographs of similar burial sites. With this in mind, a combination of outstanding light and an appropriately sympathetic viewpoint, to create a strong sense of both atmosphere and place is clearly a must. So, for this particular location, if we want the light to hit the face of the stone, then only a mid-summer's evening or very early morning will suffice: no other time will do. As for the right weather, it is almost impossible to say what conditions are 'best', although, clearly, an expanse of blue sky and a favourably placed cloud do a lot towards the compostion of this picture. As for many of the other colour transparencies in this book, even in their unfiltered and straight exposure state, they look good. Here the warmth of light, on the face of the stone, draws the eye away from the bright area of sky above and to the right. In b&w, no such luck.

2. Camerawork

A low camera position and a wide-angle lens combine to make the right composition, aided by a little readjustment of the camera position to eliminate some eyectaching detail off to the right. In camera I was careful to leave a small space between the tip of the stone and the island, and a similar sized gap between the island and the edge of the frame. In the negative the latter gap is much larger, since my viewfinder (irritatingly) doesn't show a 100% of the image. Such attention to seemingly minor detail may seem petty, but if we apply the same principle to the whole image, for example by burning-in small, unwanted highlights, the effect is greatly multiplied and the message of our print becomes all the clearer. To bring out the cloud I polarised the image. Working with a wide-angle 20mm lens, this made the right of the sky (nearest to the lightsource) look very bright. Unlike the colour image, in b&w this would need darkening. In my opinion this is done most controllably, not by a graduate filter (I never use them) but via a combination of flashing and burning.

3. Negative assessment

It should go without saying that I chose a negative with the right amount of shadow detail and one that had the best sidelighting - I had bracketed my exposures over a five minute period as the light was rapidly changing.

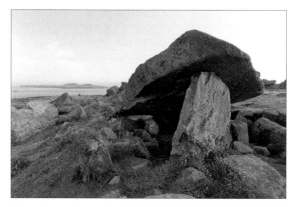

An earlier exposure, made without a polariser and when the cloud was less well defined. Bleaching it would help a little, whilst burning it in a harder grade setting would also make the right part of the print look even brighter.

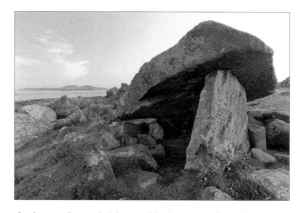

A closer viewpoint has added emphasis to the main stone and has also eliminated some distracting rocks at the right-hand tip of the stone (visible in the print above). Note also the subtle difference in the cloud, between this and the main picture on page 57.

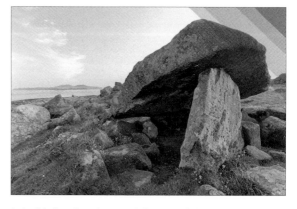

I decided to fog the top right part of the print where the negative is very dense and hard to burn-in. This is a test print, made to determine how much fogging exposure that part of the print required. See FLASHING AND FOGGING for a full explanation of the technique.

Dodging three areas of the print requires an exposure time that is long enough to make the work unhurried and therefore more precise. For this print, the basic exposure time was 32 seconds at f.8.

I burned in the left and right side at the same grade 3¹/₂ setting, before switching to grade 1 to burn-in some bright foreground details. Grade 2¹/₂ then proved right for the sky (grade 3¹/₂ might have left a dark halo along the top of the stone).

Locally fogging the top right of the print, where the negative is very dense, has helped to add much needed density to the sky. Burning-in alone would have proved time consuming. I fogged the sky at grade 2 to produce a noticeable but not too noticeable result.

4. Print exposure

Before making a print, I made a set of quite high contrast, grade 3 contact prints of all the negatives I had exposed of this one scene. Looking at these (rather than at the negatives) it was easier to detect the subtle changes of light that took place over the five minute period during which I had exposed about fifteen frames of film. In particular I was looking for the best light on the rock-face, combined with the most favourable cloud formation. The very last frame proved best. This surely makes the point that perserverence at the camera stage does pay-off. The extra cost of using half a roll of film, to get a good negative, is far cheaper and ultimately more profitable than using an unnecessary amount of paper to get what will always be a less satisfactory print. I flashed the very bright, top right part of the print (actually fogging the uppermost corner) to make burning it in easier. This technique works well with a grain-free image, such as this XP2 negative, but with a granular negative, a fogged (as opposed to a flashed) grain-free area of tone can look odd. I used a card mask for the more precise burning-in of the sky around the stone, as illustrated in DODGING AND BURNING. Burning-in that area needed to be precise to avoid a halo-like effect.

5. Print processing

Of the four or five processed prints with which I was happy, only two came out right after I had bleached the cloud. Such is the difficulty of working on delicate highlights with Farmer's reducer, especially when they are surrounded by any monotone areas, which show up even the slightest unevenness of bleaching. The reject prints I used for toning tests, since I was considering, but was undecided about using, sepia followed by gold toning, for a delicate red tone. In fact these tests showed the combined colour was too intense. Quite simply, I felt it wasn't necessary to embellish the print in this way: a more subtle, plain sepia colour looked best. After bleaching the cloud I lightened the face of the stone. This local bleaching work should always be carried out prior to toning, or uneven results may occur.

6. Print assessment

With so many rocks littering the foreground, it was imperative for the sunlight to fall upon <u>only</u> the main stone. Controlling this aspect of camerawork, combined with some creative VC printing, has made the image work the way I wanted. Subsequently, looking at the colour transparency, I have tried to visualise other ways of composing the image and so far I like to think I chose the best viewpoint.

Gwaun Valley - 2

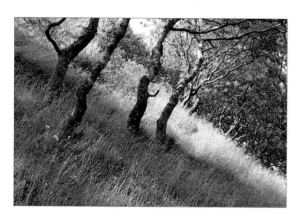

1. An unfiltered colour transparency of the scene, made just after the exposure of the b&w image.

2. A straight-exposure proof print, i.e. with no dodging, burning-in or split-grading.

3. The final print, made on Ilford Multigrade matt, FB, split-graded and thiocarbamide-toned.

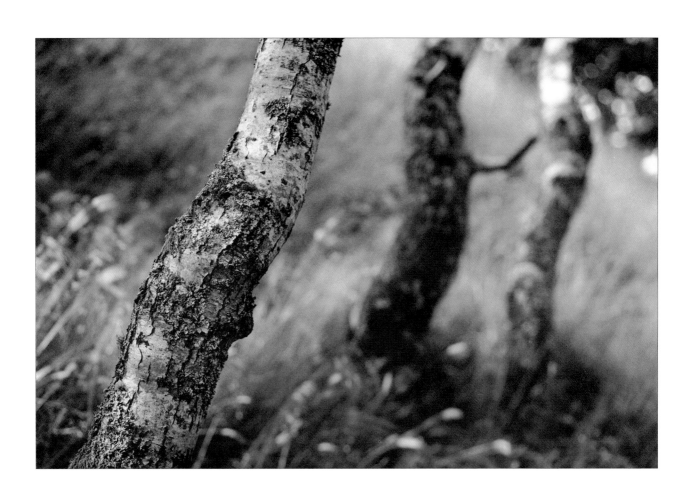

1. Image visualisation

Both this image and the cover photograph were made at the same location, as the colour transparencies indicate. It is always good to approach a subject from another angle, perhaps after we think we have already made a good image of it, since it forces us to think hard, and more creatively, about what we are trying to express. (For example, look at my various attempts at photographing the rocks at Cradle Bay.) The cover photograph is an attempt to convey the beauty of this woodland, as emphasised by the quality of light that bathed the scene in a splendid natural glow. It is an obvious pleasure that can be shared, hence its use on the bookcover. In contrast, this image is an inward expression of how I felt about the place, requiring a more individualistic approach.

2. Camerawork

The use of a limited depth of field deliberately prevents us from looking too closely at the main subject, which is not the tree to the left, but the two out of focus trees to the right. The idea I had was to use the left tree to lead the eye into the image. Its presence, and its detail, are there to contrast with the gentle shapes and form of the main subject. The result was achieved by focusing on the left tree, using a wide aperture and a yellow-green filter to lighten the grass. Before making any exposures, I waited sometime for the light to change. There had been too much direct sunlight illuminating the left tree which otherwise I would have had to burn-in, since I didn't want it to become the highlight or focal point of the image. I bracketed my exposures, using a variety of different apertures to make sure that all the left tree (but none of the background) was in focus. Using the 55mm lens, f.5.6 proved to be the right aperture, although which aperture is right does depend on the size of the final print. I also made some other exposures as the angle of the light changed, altering the look of the background. Some of these I made with an orange filter, but judging by the contacts, they were inherently too contrasty.

3. Negative assessment

I studied all the negatives with a magnifier, checking for the right amount of depth of field. To the person who uses just one frame to get their negative, bracketing one's camera exposures may seem like being indecisive and wasteful. It isn't. I have learnt so much from making prints off different negatives of the same scene. For example, it is a good way of seeing how the tonal range of a print changes when printing with over or under-exposed negatives.

In this straight exposure print there are several distracting highlights that have no detail. With VC paper we have several options for dealing with these (see below and **FLASHING AND FOGGING**).

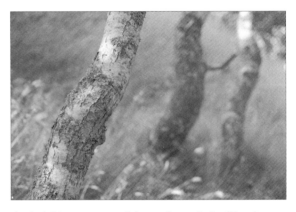

A straight exposure print, as above, but with a longer exposure and printed at a softer grade setting. This has printed-in the highlights and retained the shadow detail, but created a print that is too soft.

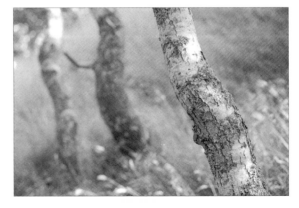

This image doesn't work when viewed in reverse, yet it does show quite clearly those areas that are too bright or too dark (see diagrams opposite). In its straight exposure state, the print is clearly unbalanced, in particular the bottom right is much too bright.

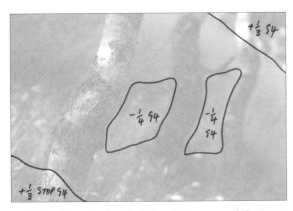

Dodging the central part of the picture around the trees has helped to make the trunks appear bolder, without the need for burning them in which could lose some valuable shadow detail.

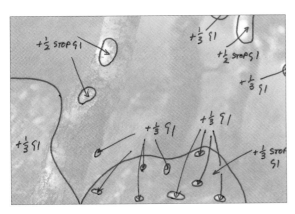

This was quite a time consuming print to make. With a basic exposure time of 30 seconds, all the additional burning-in exposures made the right VC safelighting essential if I wanted to avoid any fogging.

Rather like St. David's Head, local flashing/fogging of the upper right part of the print helped considerably towards adding much needed detail. Alternatively, burning-in at grade 0 would have worked, but it would have taken longer.

4. Print exposure

This is yet another print I would find hard to make on graded paper. Its success, like most of the others in the book, relies heavily on the balancing of the image and the toning down of distracting highlights: bright, sunlit patches on the foremost tree, the grass-heads to the left and lower foreground, etc. Working with graded paper, I would have flashed these areas, but this is nothing like as precise as being able to burn them in at a lower contrast VC setting. Also important to a picture like this is to be able to layer it tonally, so that it recedes properly into the distance. For this, the right grade of paper is obviously important, but more important is being able to split-grade the print: to burn-in areas at different contrast settings to get the desired, balanced result. But successful printing involves more than using VC paper. It relies on our interpretation of the negative and <u>then</u> it depends on the right paper and grade(s).

5. Print processing

After processing the print I viewed it on the sink splashback as usual, paying particular attention to the density of the highlights, especially those distracting ones that I had burned-in. I knew that after toning the image, their shift of colour would make them appear brighter, such is the effect of introducing colour into a b&w print. Did any of them need more exposure and if so, would that necessitate altering the print anywhere else to balance the effect? Turning the print upside down provided a good indication, as always, of how successful I had been in balancing the image (turn the book upside down to see what I mean). Ater a brief rinse, I locally bleached some darker parts of the left tree trunk, which appeared to be drawing attention away from the more important darker base of one of the out of focus trees. After using the Farmer's, I washed the print, hypo cleared it, washed it and toned it in thiocarbamide sepia toner.

6. Print assessment

I particularly like the right-hand side of this print which is out of focus. Were I to make the picture again, I would also experiment by exposing some film with the camera lens thrown completely out of focus. It seems to give the image a very restful, quite dreamlike quality. (Try cropping out the left side to see what I mean). Alternatively, I would use a relatively slow shutter speed and gently jog or move the camera as it is exposing. Whatever the method, it's clear that sharpness does not always best describe a scene, or the way we feel about it - our interpretation of it is far more important.

Wreck - 3

1. An unfiltered colour transparency of the scene, made just after the exposure of the b&w image.

2. A straight-exposure proof print, i.e. with no dodging, burning-in or split-grading.

3. The final print, made on Ilford Multigrade matt, FB, split-graded, thiocarbamide and blue-toned.

1. Image visualisation

Of all the colour transparencies in the book I find this one the most interesting. Why? Because I remember nothing of the colour of the scene from the time I made the camera exposure and yet look at the extraordinary variety of colour in the transparency. What I was aware of at the camera stage was just the various shapes, forms and textures. I was conscious of how the quality of light affected these in b&w, for example how it picked out the cogs of the wheel, but also how it illuminated various unwanted elements within the scene. For example, the small bright, central piece of seaweed, which I knew I would have to print-in and which I knew I could deal with in the darkroom with VC paper (using a low contrast filter setting). In the colour image, this bright yellow object is important, adding to the already enormous variety of colour. In the transparency the colour of the scene (its natural beauty) is more important than the artifical shapes of the man-made composition. In b&w, of course, the opposite is true.

2. Camerawork

The tide was coming in fast, so I had to work quickly, and in retrospect too quickly (see PRINT ASSESSMENT). Being aware of the extreme brightness range of this subject (i.e. the difference in luminance between both the brightest highlight and darkest shadow detail that I wanted to render visible), I realised that I would have to combine camera and print exposure techniques. I thought it likely that I might have to fog the print, to put plenty of tone into the brightest, sunlit highlights, if I wanted to split-tone the print, as I had hoped - using blue over sepia, to create warm highlights and blue shadows. I made the image with a 55mm micro lens, without a filter, hand-holding the camera at a shutter speed of $1/_{125}$ second at f11. Why didn't I use a tripod, as I have with all the other images? There wasn't the time: the tide was coming in around my feet, with waves breaking over a mixture of rocks and tangled metal. Besides, $1/_{125}$ second for a 55mm lens is fast enough, $1/_{60}$ second wouldn't be.

3. Negative assessment

I only had one negative from which to choose (a far from ideal situation). Because I had hand-held the camera, all the images varied slightly in composition and this one had the most room at the bottom of the frame, which seemed to balance the image much better. Fortunately I had downrated the whole film to ISO 200 (over-exposed it by one stop), so the XP2 negative of this contrasty scene was very printable.

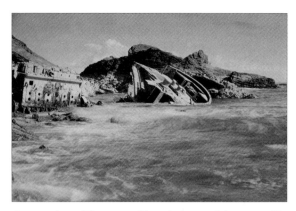

An overview of the scene. The whole wreck is covered in small barnacles, giving it the same natural colour as the surrounding rocks. This could have provided the basis for an interesting colour image.

A very low contrast print, given enough exposure to render some tone in the highlights upon which the thiocarbamide toner could work. But the overall contrast of this print is too low.

Another image which doesn't appear to work when viewed in reverse. However, in its straight exposure state, this print tells us the top right-hand side is too bright. If in doubt, cover this part of the image and try to imagine how it should look: darker appears right.

66

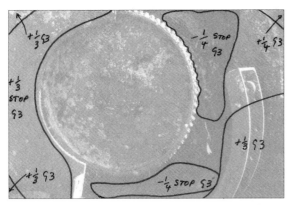

Blue toner builds up contrast and darkens shadow detail so I was sure to dodge the shadows of this print. A print that looks well balanced in b&w may become out of balance when toned.

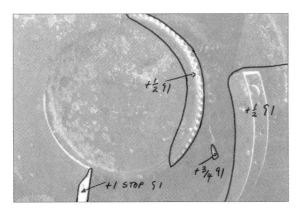

Printed at grade 3, I burned-in various parts of the image at the same filter setting, to get the right overall balance, before switching to grade 1 to burn-in the strongly side-lit highlights.

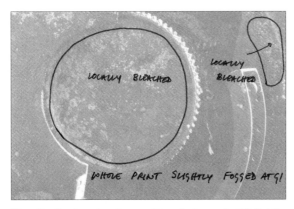

Despite the burning-in mentioned above, I still lightly flashed/fogged the print to make sure I had plenty of highlight detail for the thiocarbamide toner. I wanted rich brown highlights to contrast with what would become strong blue-green shadows.

4. Print exposure

Split-grading the basic print exposure would be my chosen approach for an untoned print. However, I decided to fog the print for the split-toned image I had in mind. In b&w such a print would look veiled and a little muddy, but with the introduction of colour into the highlights the apparent contrast of the image would be lifted. I made various test-strips of this image to see how much burning-in some of the bright highlights needed to really darken them down. If I had more time and conditions had been better, I would have used a tripod and flagged the light falling on the bright strand of seaweed. It would have made printing much easier. It is easy to forget that we can control outdoor lighting with subjects such as this both on location and in the darkroom with VC paper. It's hard to explain how to print an abstract subject such as this. Unlike a conventional landscape, there is no clearly recogniseable natural order to guide us.

5. Print processing

I used Multigrade developer, diluted 1+9, as usual, followed by a plain (non indicator) 2% acetic acid stop and then two baths of Hypam fixer, diluted 1+9, with the print in each for just one minute. A non indicator stopbath is useful for helping to evaluate delicate highlights: I find the yellow indicator variety temporarily discolours FB paper (until it has been washed for a while), making print image density hard to read. After a brief wash, hypo-clear and then an hour's wash, I thiocarbamide-toned the print to produce a warm brown tone, but only in the highlights; i.e. I didn't bleach the print too far, so that only the fogged highlights and upper mid-tones accepted the toner. After another hour's wash I blue-toned the print, toning it until just the shadows and lower mid-tones changed colour. I washed the print until the white margins had no residual discolouration from the blue toner, then I air-dried the print.

6. Print assessment

I was attracted to this subject by the side-lighting and the way it - so obviously - struck the flywheel, making it stand out very clearly. Yet, with the benefit of hindsight I would have made the image at least an hour earlier when there would have been no direct sunlight falling on the scene at all. In that way I would have relied on more subtle creative printing techniques to subtly draw out the various shapes and forms in a less obvious, but ultimately more successful way. I think the side-lighting maybe gives the print an overstated feel. A rich, textured image, that gently draws the eye into even the darkest shadows would speak more of shapes <u>and</u> textures.

About my photographs

Acquiring images - seeing subjects too photographically - b&w versus colour

As a photographer, too often I find myself slipping into tourist mode - collecting images acquisitively as if they were some kind of souvenir, to be enjoyed later at home through the print. It is an attitude I dislike: I prefer to come away from a location believing that I have put something of myself into the place, that the process of camerawork was more of a shared experience of give and then take. This isn't some kind of religious school of photographic thought, rather, it is my way of making myself record better, on film, exactly how I feel about a place; it is that shared experience, rather than the mere 'taking' of a picture, that I wish to convey. I like to think that at least some of my landscapes succeed in sharing that sense of 'being there'.

I like to be able to look upon my prints as meditative: calming - a way of discovering things about myself by looking at what I've found with my camera and then interpreting this through my making of the print. I am dissatisfied with a photograph if I feel I haven't learned something new from it - this applies to my own work and looking at that of others. That said, I would say there's usually nothing special about what I see, but I like to think that there may be in what I feel about a place and it is that quality, as I've just mentioned, which is the one I try hardest to communicate through my prints, much of which is said by what goes on in the darkroom. I feel comfortable there; I feel the paper and I start from the same blank point, both unsure of our potential, that gradually - given the right approach - we reveal something of ourselves.

What else don't I like about my work? Too often I find myself looking for obvious subjects rather than allowing them to unfold. Very often I see shapes and textures and patterns in a predictable, formulated, photographic way, rather than allowing my inner thoughts and emotions to take control (it's safer and easier that way). This is often reflected in my "chasing the light" - when I see better light somewhere else and go after it, ignoring what's around me because it's less obvious. In that situation, to see what's around me requires more input and a greater confidence in my own abilities.

Good photography requires a lot of confidence, rather than formulated technical bluff, or too great a reliance on the subject's inherent beauty, as emphasised by the quality of light rather than by an individual's quality of vision.

And yet, I would say my photography is often too much about trying to take control of the landscape, of trying to shape it into my way of seeing - of making it into something it isn't. I don't want to produce a contrived view of the land. I want to show it for what it is and how I feel about it. And yet the 'better' I get at photography usually the more dissatisfied I become with my work, since my rate of technical improvement isn't usually matched by my personal growth and the development and expression of my ideas. Why not? I guess it is easier to learn techniques. And yet ironically I am far more interested in images than in photography.

Sometimes, when I look at my photographs, I feel ignorant and incommunicative, yet I don't want to resort to words and captions - to elevate my pictures to an unwarranted status. Yet, I never want to be so happy with my images that I might be blind to them and therefore look upon them as finished statements. No finished print is a complete statement. There is always room for improvement and reinterpretation, but this is not to say that reprinting a negative, to get a 'better' print, is necessarily a good idea. What we have learned from making one image we should apply to the next.

Of the pictures in this book, which do I like the most? I suppose the cover picture. I see it as a very personal statement about a very special place. I don't see that anyone else would do it the same way, which is not to say that my image is better, it's just to say that it is one individual's very personal reflection of a landscape, as I hope anyone else's picture of same the place would be. I also like Ramsay Sound, since I feel it reflects my belief that my landscapes should be more than a visual catalogue of places I have visited. As I have said, I am not always interested in merely recording the quality of light, or the colours of a scene, or the splendours of nature; that I would usually prefer to leave to memory or to colour film. Instead, through the use of VC paper and variable contrast control, I like to cast my own 'light' upon a subject, to produce a b&w image that speaks more eloquently than any graded paper print, or more intimately than a machine-processed colour transparency.

In the case of Ramsay Sound, the colour of the scene was quite overpowering. A colour image could have relied almost entirely upon the warmth of the light of the setting sun, falling upon the clouds,

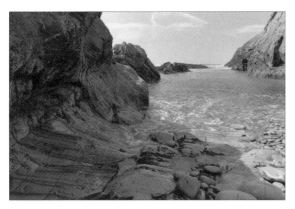

This subject is halfway there towards making it as a b&w picture, but there is is too much wrong with it that can't be easily corrected in the darkroom: for example the irregular cloud formation. Also the water movement in the foreground is nothing like as pronounced as it needs to be to make a truly eye-catching print. Even bleaching the water wouldn't give it enough emphasis. In a word, the picture is "untidy". Besides, it lacks emphasis.

Me at work photographing Gwaun - 2. The steepness of the slope is apparent, yet in the b&w image it is far less noticeable. It is very easy to be taken in by elements of the subject that look good to the eye but which are lost to the 2-dimensional view of the camera.

contrasting nicely against the cold blue of the sky (as even the unfiltered colour transparency on page 32 clearly shows). In b&w such opportunity is lost. Instead, I chose to play upon the highlighted nature of the cloud, accentuating its shape, by polarising the image (as I would also have done in colour, but to saturate its hue). I anticipated that in printing I could further enhance the cloud by printing down the right-hand side including the water, to give the impression of light striking it from low down, at horizon level, from behind the cloud bank.

Through my composition of the image, using the line of the shore, leading in from the right, and the detail of the lower foreground (dodged and bleached back), leading in from the left, I wanted to take the eye into the picture, up to the horizon and then up to the cloud - to say something of the sense of scale of the place. To this effect, a 20mm wide-angle lens was right. By split-grading the print, to add contrast and density to the shadow values, I was able to darken the area of rock in the middle distance, to act as a pedestal upon which the cloud could sit, without having to burn it in.

In b&w, I believe I can say more about how I feel about being at a place like Ramsay Sound, as opposed to what I think I could merely describe with colour photography. This may seem an unfair criticism of colour photography, but as a process, it doesn't offer me the creative freedom of expression, that extends beyond the mere recognition of the colours or splendours of a scene. Colour photography deals very precisely with the event of the moment, whilst with VC paper I can make a longer lasting statement.

Where do I see my photography going from here?

Well, to date, I would say my camerawork has been fairly traditional in comparison to my approach to printing, since it is easier to devote time to developing darkroom skills than it is to be out on location. Therefore I would like to spend more time outdoors image making, attempting to discover (better) what it is that I feel about the landscape that I would then like to translate onto film. Very often I photograph a subject unaware of exactly what it is that I am trying to say and therefore not knowing how best to express it through camera techniques and composition. Ask most photographers - I'm sure they think the same way.

"Do I tone all my work"? is a question I am always asked. Answer, "No". I would like to make a complete series of untoned b&w prints, being almost totally reliant on camera skills, as opposed to camera <u>and</u> darkroom skills, to further develop my eye.

History & theory of VC's

Filtration - emulsion types - silver content - paper construction - optimum results

Surprisingly, VC papers have been around for over 50 years. Ilford announced the first paper in 1940, whilst the idea had even been muted as early as 1912 by one Rudolf Fischer. Why then has it taken so long for them to gain recent popular acceptance? Only now do they account for 75% of the b&w paper market.

The first VC paper comprised two emulsions of different contrast and different colour sensitivity, being responsive (like today's papers) to green as well as blue light - graded papers are just blue sensitive. Unfortunately image colour changed as the contrast of this two emulsion paper was altered and one or other of the emulsions predominated. This is no longer true. Also, the first papers could not produce a print with the equivalent contrast of a grade 5 paper. (Multigrade VC numbers correspond with Ilfospeed graded - not all VC papers are the same.) Early VC users will also remember the inconvenience of having to calculate revised exposure times for each change of contrast grade using an exposure calibration dial. Nowadays, VC enlarger filters, which are made by coating dyed gelatin onto a high quality clear polyester film base, have appropriate built-in neutral density filters. These ND filters ensure that exposure times are consistent for all grades from 0-3$^1/_2$, so that all we need is to double the print exposure time for grades 4-5. Better still, using a Multigrade enlarger head like Ilford's, exposure times are the same for all grade settings.

How does VC filtration work? Quite simply, by using magenta and yellow filtration. A magenta filter only transmits blue light to give a high contrast image, whilst a yellow filter only transmits green light to give a low contrast image. This filtration can be applied with a colour enlarger with dial-in filtration, or with above or below-the-lens VC filters, or alternatively a VC enlarger head can be employed. In some cases, for example with Kodak's Polymax paper, dial-in colour head filtration, using magenta and yellow filtration, will not yield the equivalent maximum contrast range possible with the Polymax filters. Those wondering why Ilford's Multigrade heads now use a dichroic blue filter instead of a magenta one and a dichroic green instead of a

yellow one, might like to know that they eliminate the transmission of infra-red rays, reducing the risk of overheated negatives which might otherwise move during exposure. Their use also reduces the risk of heat damaged negatives.

Soon after the introduction of the first VC paper, Varigram, a single emulsion paper with a mix of emulsion components, was introduced by the Defender Company (later part of Du Pont). Like all subsequent VC's, this gave a consistent image colour for all contrast grades. For example, the current Ilford Multigrade has three components. Each is sensitive to blue light, but they are sensitised to green light to different degrees. These three components are all high contrast in nature, so that when exposed to blue light they will produce maximum grade 5 contrast, but exposed to green light the components have different speeds and produce a lower contrast image. In all cases, all three components are exposed so there is no loss of D-max. (Tests I have made show that some makes of paper still do not attain a true grade 5 - see AG+ VC REVIEW, due to be published spring 1995).

Ilford Multigrade, for example, has a chloro-bromide emulsion like a warm-tone graded paper. Yet its neutral image colour stems from the sizes of its silver crystals and the extent of emulsion hardening: high speed and high contrast require larger crystals which give a cold to neutral image tone. Sufficient hardening, to withstand physical damage during processing and drying, also makes for a cooler image tone. Interestingly, Multigrade developer was originally formulated to prevent an excessively cold image colour with earlier versions of Multigrade paper. For today's Multigrade, Ilford say that any paper developer will work to produce a neutral-tone image.

Why is it that until recently most VC's have been neutral rather than warm in tone? To quote one technical service personal: "I don't think that I'm giving away very many secrets if I admit that making a warm-tone VC product represents a tough technical challenge", for example, note the relatively low maximum contrast of Forte's chloro-bromide warm-tone VC paper.

The ever present question of silver content has led some users to speculate that VC's have always possessed less than graded papers and that automatically, without question, this would make them an inferior product. In fact, above a certain quantity, no extra amount of silver will produce a higher D-max. Ilford quote the case of a 1970's US FB paper, coated with 2.46g/m^2 of silver, that produced a D-max of just 1.93. Compare this, they

say, with a 1990's German RC paper coated with just 0.86g/m² which produces a D-max of 2.06. Current Ilford Multigrade and Agfa Multicontrast are both coated with 1.5g/m² of silver. What affects D-max more is the degree of emulsion hardening and crystal size: a softer emulsion gives higher maximum density, so do smaller crystals. Unfortunately physically softer emulsions usually need to be hardened, during or after fixing, to prevent physical damage especially with contact methods of heat drying. This is not always considered good archival practice, whilst adding a hardener to the fixer inhibits washing and can affect toning performance.

That said, silver quantity will affect exposure and development latitude. Most significantly, the greater the amount of silver the more a paper can be pulled and pushed (in conjunction with over and under-exposure) to create a lower or higher contrast image respectively. Typically + and - $^1/_2$ grade changes in print contrast can be achieved in this way with high quality FB papers. However, with the contrast control of VC papers this is best achieved through changes in enlarger filtration since push and pull print processing affects the tonal range of the image. In particular, pulling - when coupled to extra exposure (to compensate for the shorter development time) - tends to cause some blocking up of shadow detail and may cause a drop in D-max. It also tends to warm up image colour as the reduced development time prevents the silver crystals growing too large.

The general construction of VC papers is like that of graded: an emulsion of gelatin (animal product) and silver crystals is coated onto a baryta (barium sulphate) layer of about 20-45g/m², itself coated onto the paper base. This layer stops the emulsion soaking into the paper, thereby improving definition and increasing D-max. It also improves the whiteness of the paper, whilst a paper like Kentmere's graded Art Classic has a coloured pigment added to the emulsion to enhance the warmth of the paper. On top of the emulsion lies a gelatin supercoat layer which prevents the emulsion being fogged by friction and helps reduce the likelihood of physical damage during and after processing.

Typically the weight of a double-weight (DW) VC FB is about 240g/m², whilst that of a single-weight (SW) is about 185g/m². SW papers, which are quicker to wash and which were traditionally used for more rapid processing work, have largely been replaced by Resin Coated (RC) papers which have a similar construction to FB's although their support is made up of a layer of paper sandwiched between two layers of waterproof polythene. Interestingly, the laminated construction of earlier RC papers was thought to affect their long-term permanence. Due to improved manufacturing techniques this is no longer true. However, it can be said that some RC's are not so easy to tone. In certain cases this may be due to the way that some are chemically rather than physically finished. Also, the fact that many RC's are developer-incorporated, for rapid machine processing, can limit development flexibility.

Today's VC's show other improvements. As for graded papers, prolonged washing is less likely to cause a slight discolouration of the paper or a loss of brighteners added to the paper to improve its whiteness. Earlier VC's also tended to suffer from poor latent image stability, i.e. if the print wasn't processed soon after exposure it would gradually start to appear underexposed.

To get the best results from any paper, its characteristic curve should fit, as closely as possible, that of the negative being printed. Considerable improvements have been made in this area. For example, with the current range of Ilford films, shadow detail is rendered even better than before when used with the latest Multigrade paper, which also makes it easier to print what have been described as the "difficult to print T-grain Kodak films". Equally important to print quality is to properly store unexposed paper, ideally below 20C and at a constant temperature, in an environment of between 50-60% humidity. Incorrectly stored paper may show a loss of both contrast and speed, a slight yellowing of the whites, some fogging (veiling of the highlights) and even a slight loss of glossiness. Carefully sealing the packet, and even deep-freezing it, is good practice if the paper is to be kept for a long period, but the image colour of warm-tone papers will gradually cool as the emulsion continues to harden even in low temperatures after the paper is made. Incidentally, refrigerated paper should be allowed several hours to reach room temperature before the packet is opened.

Just as for graded paper, it pays dividends to use the 'best' grade. For most makes of VC paper, grade 2 is usually considered the best: unlike much harder grades it exhibits good exposure latitude, which makes for less critically controlled burning and dodging, and unlike softer grades it tends to show what I would call better "micro contrast" which enhances the apparent sharpness of the image. If you like high contrast prints, it is better to increase the contrast of your negatives and print on grade 2 rather than print on grade 5.

Darkroom equipment

Enlarger lightsources - filter sets - darkroom layout - print viewing systems - safelighting

Much of what needs to be said also applies to graded papers and has been extensively covered in other books, e.g. CREATIVE ELEMENTS. However, the right enlarger lightsource is especially important for VC's, in particular to get the maximum contrast range from the paper and for consistent exposure times for the various grade settings.

Since all VC papers are designed for use with tungsten or tungsten halogen lightsources, the one lightsource I would avoid is cold cathode. It has a very blue light designed for graded papers, which, for VC's requires the addition of a 40Y colour correcting (CC) filter. Typically this CC filter will have to be put under the enlarging lens, along with the VC filter, potentially degrading image quality a little. Its presence will also increase the print exposure time in addition to what may already be quite long exposure times (especially for 35mm negatives) since many cold cathode enlargers are old (with ageing, weaker tubes). Besides, they are rarely suited to negatives less than 5"x4" in size. In particular, what I don't like about cold cathode lightsources is that they need to be left on all the time, to keep the bulb at its optimum temperature, for consistent print exposure times. That said, like a diffuser enlarger, they do produce prints with a lovely, even tonal range and delicate highlight detail.

Nowadays I print virtually all my work using a diffuser lightsource of the colour head or Multigrade head variety. A condenser head gives sharper results but I have found enlarger lens quality is more important, which also means using the lens at its optimum aperture - usually closed down by 3 stops. That said, with the exception of XP2 dye (as opposed to conventional silver) negatives, a condenser head gives about a grade more contrast than a diffuser, which can be useful for very thin negatives, but this shouldn't be necessary if negatives are correctly processed. However, for some makes of paper that don't give a true grade 5, this extra increment of contrast may be useful. As we know, condensers also show up scratched and damaged negatives, accentuate negative granularity and often make print highlights look burnt-out. Dust,

or any marks, on thin, underexposed or underdeveloped negatives will show up most with a condenser head. Also, negatives are more likely to 'pop', by expanding towards the heat of the condenser bulb than with other 'colder' lightsources.

Printing with a dial-in filtration colour head is simple enough, although we have a choice of two methods of filtration: one uses just yellow or magenta filtration, but it doesn't give quite the same speed for each grade setting and therefore needs testing. However it does give a higher effective speed than the second method which combines yellow and magenta filtration to give consistent exposure times for grades 0-4. Grades 4-5 then require double the exposure time. Different makes of dial-in colour heads fall into three categories: Durst, Kodak and Agfa. (See the tables at the back for a full list of makes, plus filter values.)

If you don't have a dial-in filter colour head or a Multigrade-type head then you'll need a VC filter set. These are available in different sizes, suitable for either below-the-lens or above-the-negative use. The former do not interfere with image quality if kept clean. In fact, I prefer the below-the-lens variety since changing filters mid-print with them is less likely to disturb the enlarger, thereby avoiding a double image upon the second, or consequent exposures. For the below-the-lens variety, both Ilford and Kodak produce kits whose filter holder simply clamps onto the enlarging lens. These filters give maximum contrast control, whereas some colour heads may not give a full grade 5. Incidentally, the most recent Kodak Polymax filters are less opaque than Ilford's, giving a slightly higher effective paper speed.

Just about the most important aspect of darkroom layout is the ability to view prints and test-strips properly. A still too common mistake is to make the print viewing light too bright and its illumination too direct, as to artificially brighten the image and flatter its tonal separation. This effect is exacerbated by the way all prints dry-down darker after processing, fibre-based prints especially (15% or more) and matt papers in particular. The latter suffer badly from a loss of shadow separation as the paper dries and loses its watery, glossy sheen - the apparent D-max of a wet, matt-surface print can be the same as for a gloss print, e.g. 2.2 but may be as low as 1.6 when dry.

To help counter this problem, the viewing system I use employs a slightly diffused, standard, household, opal tungsten light hung from the darkroom ceiling. It's not too close to the print (about 6-7 feet away) and throws light in all directions, not

Darkroom equipment doesn't need to be complex or expensive to get the very best results. Here, we can see simple dodging and burning-in tools in action. Likewise, the very best results can be achieved with under-the-lens VC filter kits, without the need for special filtered lightsources.

just at the print - as with a spotlight. It illuminates the entire darkroom so that everything around the print competes for attention as if the print was hanging on a living room wall. I view the print under this light against the sink splashback (whose plastic is a light, approximate 18% photographic grey-card tone), and then in shadow, under a shelf that rests above the darkroom sink. If the print is too reliant on the quality of illumination, and has little inherent luminosity, then it will 'die' in this shadowy, lower contrast light. But this is not to say that the print should be made brighter, with less highlight detail and more paper-base white showing through. Most likely, it is the amount of shadow detail and its degree of tonal separation that is lacking and which normally gives luminosity and depth to a print - remember prints should glow rather than glare. Look at some old photographs, for example the work of Steiglitz and Steichen, and you will see what I mean; their prints are really rich.

To help assess image colour/tone I have another similar light, but fitted with a cooler daylight simulating tungsten bulb (available from art shops), that equates to north light in colour temperature. (The blue filter covering these tungsten bulbs balances their warmer, lower colour temperature.) It is best not to use fluorescent strip-lights, whose power output varies as they warm up, and which glow after they have been switched off potentially fogging film. Unless they are daylight-balanced, they also have a strong colour cast, as anyone photographing colour interiors will well-know. However, a daylight balanced flourescent tube, located out of the darkroom, does act as a very testing lightsource, since it is very diffused in nature, and does not exaggerate the contrast of the print.

Another useful aid, which I have recently discovered whilst working in a friend's darkroom, is to have the space to stand back from a print. Most darkrooms are small confined rooms, that only allow intimate contact with the print. Viewed from some way back, many prints look flat and lifeless, which is a good indication of how they may appear when dry.

Whilst making my prints I also use the minimum amount of safelighting: just enough so that I can locate dodgers and burning-in cards but not too much light as to throw shadows over the print, which might distract my dodging and burning-in work. Too much safelighting also makes it hard to focus the image, or to see the denser negative highlight areas while burning-in. Communal darkrooms always seem to have safelighting that is too bright.

To prevent highlight degrading fog with VC's, it is essential to make sure that the right safelight is used, that it is no closer to the easel or processing dish than the manufacturer's recommendations (usually 4 feet), and that the maximum safelighting time is adhered to. This time starts from when the paper is removed from the packet to the moment of its entry into the stopbath. If the maximum time is, say, 4 minutes and the print is being developed for 3 minutes then, under normal safelight conditions, we only have 1 minute left under the enlarger to make the basic print exposure and any other exposure manipulation work. Moving the safelight further away, or using a weaker bulb will then be necessary.

Finally, I like to work in a straightforward, systematic and uncluttered manner. This means having a space laid out in a simple, yet logical way, with the bare essentials of equipment, so that I can concentrate on what I am doing, instead of how I should be trying to do it. For me, the actual process of darkroom work should be intuitive - it should be second nature.

Dodging and burning

Creative control - the tools - techniques - different grade settings

Even if we want to photograph a scene exactly as it is, because our view of it is always partly subjective, we usually have to manipulate the print by dodging and burning-in, i.e. locally reducing and increasing print exposure respectively. Besides, film and paper do not record images in the same way as the eye, nor is the camera capable of perceiving things in the way of the human mind. And, in the unlikely event of a negative being 'right', there is benefit to be had from giving at least +$1/4$ stop of extra exposure to each edge of the print. It subtly holds in the image that little bit better. In fact, I can't ever remember making a straight exposure fine-print.

What tools do we need to dodge and burn-in prints? For dodging I use pieces of black card taped to very thin, non-shiny florists wire. The idea of using bicycle spokes or coathangers to hold the card has been popularised by many practitioners but they can cast unwanted shadows; also light can reflect off them to fog the print. A variety of dodgers, of different shapes and sizes, is a must for serious printing work, but I certainly would never go the unnecessary expense of buying a kit. For burning-in, I always use sheets of flexible card to mask those areas not requiring any of the additional exposure. These cards can be bent, twisted and moved during exposure to gently grade-in the burning-in work.

Dodging and burning aren't just corrective tools, they are expressive means of communication. With them we can alter image balance and composition to our own liking, to give greater meaning to our prints, by drawing emphasis towards or away from certain areas. But, we don't always need to 'shine a light' on a subject, by dodging or burning-in to see it better. Dodging a key area of the print often does more than draw attention to it: it can draw unnecessary attention to it, especially if that part of the negative is too thin. It can reduce its contrast, making it eye-catchingly weak. It is a common mistake. Better, perhaps, to burn-in other areas to achieve the right balance of tone, or to work on the dodged area at a higher contrast VC setting to keep the blacks looking black, or maybe to locally bleach them as well, for a similar effect. For example, rather than make an area lighter, which may cause it to look too weak, we can darken an area beside it, or around it, to make it look <u>relatively</u> brighter. Alternatively, we can dodge an area then partially burn it in at a higher contrast setting. For example, we can dodge for $1/2$ stop at the basic exposure contrast setting, then burn-in, say for $1/4$ stop, at a much harder setting.

So much dodging and burning-in work we see is crude: too direct, too obvious - simply too photographic, reliant on the physical black and white properties of the paper to give the image somewhat artificial light and life. Just as we should not be afraid of placing our subjects on the very edges of the frame, so we shouldn't always try to tonally place the subject 'centre-stage', by dodging it or burning it in to make it sit in the middle of the print's tonal range. It pays to let the eye find the subject's proper place in the image.

Of course, working with VC's, we have the option to dodge and burn-in at the same grade, as with graded papers, or at different grade settings. Working at the same grade is quite simple; how much we may need to dodge or burn-in is worked out by making some + and - exposure test-strips, having first made a test-strip of the correct exposure at the right grade setting for the negative. From these we can determine how much dodging an area can tolerate before it starts to look weak, and how much burning-in is needed to render other areas visible or more noticeably visible. This is a much better method than guesswork. Once the dodging and burning-in times have been ascertained, we can incorporate them into a printing plan to help make our final print.

However, there are problems associated with burning-in at the same grade setting. Any light overspill can create an all too noticeable halo effect around the worked-on area; it can also accentuate print graininess, usually where it is least needed and most easily seen, i.e. in the highlights. Dodging the print at the same grade setting can create weak looking areas of lower contrast, because it is usually these areas (of lowest density and therefore poorest tonal separation in the negative) that we need to dodge.

Dodging and burning-in at different grade settings provides the option to greatly enhance, or further subdue, certain areas of the image. For example, we can burn-in overly bright highlights at a lower contrast setting. Any light overspill will be less noticeable and print graininess will be minimised. Using a lower contrast setting will also add greater subtlety of tone to these areas which often benefit from a more delicate approach. Softer grades are

A black border is a popular alternative to burning-in very dense negatives, for example to hold in burnt out skies in landscape prints. Here I used the technique to link various elements of the picture.

Dodging is simply carried out with a piece of black card attached to a thin wire. A variety of shapes and sizes, (round, rectangular and triangular) should cater for most situations, whilst moving the dodger and or holding it closer to the lens will graduate its effect.

I frequently use printing masks, made from old double-weight reject FB prints. Here the mask is held close to the baseboard for precise effect. To make the mask, simply project the focused negative onto the card, trace the outline and cut out the shape.

also more tolerant of exposure errors, since their exposure latitude is greater. Using a softer grade, it is possible to burn-in bright areas without areas within them, that are already visible, becoming unnaturally dark and heavy. For example, we can burn-in the sky of a landscape without the branches of trees becoming black and detailess.

It is possible to deliberately over-dodge certain areas during the basic print exposure and then to burn them in at a harder grade setting, to put back more contrast and enough density. For example I have dodged the foreground of landscapes, then burned them in at a harder setting to lift them and to add a greater sense of depth to the scene.

Judging how much to dodge or burn-in takes more skill than looking at test-strips. Lighten one area and the balance of the print may be affected. We may need to compensate for it by working on another area, and so on. I have made prints of up to 25 or 30 separate exposures and at three different grade settings to get what I thought was a natural looking result. The process may seem never ending, but the aim is to make the picture look seamless, as if it was easy to make. The purpose of photography is to make an image, not one that is obviously photographic, or one that looks contrived: that says "look how hard this was to print". Is that the message we want to give through our photos? No. I dislike any of my prints that look worked on; very often fixed-grade prints look that way.

For maximum control, I like to work with a basic exposure time of usually no less than 10 seconds. This means that if I am $1/2$ second out with my dodging it will represent far less of an error than being $1/2$ second out on a 5 second basic exposure. Also, hold the dodger static for the briefest of moments during too short an exposure and its shape will appear all too clearly in the print. The same principles apply to burning-in work. Also, more care needs to be taken when dodging or burning-in harder grades of paper; their more limited exposure latitude makes them far less forgiving of exposure errors, for reasons already explained above. With this in mind, it is best to produce negatives that print up best on grade 2 of most makes of paper.

Dodging and burning-in provide us with another chance to control the image, to override what the camera purely recorded, to go beyond saying "this is what I saw", to say "this is how I see it and how I wish to express it". Rather like subtractive and additive studio lighting techniques, they help us to eliminate what isn't needed, and to enhance what is, so that people can read our images in the right light: that is in the 'light' we intended.

Rather than use a purpose-made dodger for the shadow under the burial stone, I used I simple round-shaped card, which I moved during the exposure, to create a graded-in dodging effect.

Two cards, both with square holes cut in them, laid one over the other and held at right angles to each other, to create a triangular hole, worked well for burning-in the right-hand side of The Cradle.

As for the above-opposite picture, I used two cards to burn-in the sky of The Cradle, moving the cards to grade-in the effect.

I often burn-in all the edges of a print to help hold it in. Sometimes this might be at a different contrast setting. I always use the edge of a piece of card for this job.

Dodging the sunlit central rocks of The Cradle during the basic exposure with a small card dodger, before switching to a larger dodger for the left-hand rock face, necessitates a reasonable length exposure time.

A single sheet of card, of about 280gsm in weight (i.e. a little heavier than double-weight FB paper), can be flexed to enable burning-in or dodging of larger areas of the print. Here I am burning-in the sky of The Cradle.

Burning-in the sky of Gwaun - 1 (as per the picture of The Cradle opposite). Here the filter has been changed to a lower contrast setting, as explained with the printing diagrams accompanying the picture.

Burning-in the right-hand side of Gwaun - 1. I find working with cards a more accurate way of manipulating a print rather than using my hands, which seems to be the more conventional method.

I tend to watch the card rather than the easel when burning-in areas of the print. Since the card is nearer the lens, the projected image is brighter and easier to see.

Dodging Gwaun - 1. We can use test-strips to work out how much dodging an area might need, but putting this information into practice requires much practice.

Again, using a flexed card to burn-in the right-hand side of Gwaun - 1. Trying to carry out this type of work just using one's hands is not easy and, in my experience, rarely is it repeatable.

Burning-in the central, bright area of grass in Gwaun - 1 using just my hands has left the lower part of the print exposed to unwanted image forming light and this is with the small 10x8" prints illustrated here.

Split-grading

Contrast and tone control - overall and local techniques

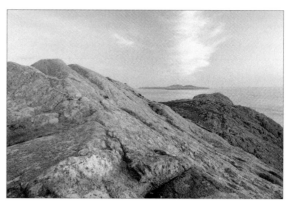

A straight exposure print of Ramsay Sound, made at a grade 2 setting.

Traditionally, working with graded papers, there is a limited amount that can be done to alter the tonal range of a print, either overall or locally, other than by flashing, or by two-bath or water-bath development (which can all be used with VC's). Changing enlarger lightsources, for example switching from a diffuser-type head to a contrastier condenser unit, can also help a little, but, nothing like as much as using a Multigrade-type head, or VC filters, combined with split-grading a VC paper.

There are a number of split-grading options. The basic exposure time can be divided into two parts, the whole print being exposed at a different contrast setting for each, or the basic exposure can be made at one contrast setting with any subsequent burning-in exposures made at other filter settings, or a combination of the two can be used in varying degrees. But why, exactly?

We can use the technique to emulate the tonal range of other papers, both old and new. For example, some older papers were thought to produce more delicately rendered highlights. In fact, we can add extraordinary delicacy to the print highlights by making part of the basic print exposure at a lower contrast setting, and we can add greater shadow separation by using a harder filter setting in the same way.

Split-grading also helps to improve print shadow and highlight separation by overcoming an inherent deficiency of all films. If we look at their charateristic curves we will see that they are not entirely straight, in particular the toe and the shoulder are curved. This means that for each unit of film exposure these parts do not produce an equivalent increase in density in the negative when compared to the middle 'straight line' portion of the curve. Put simply, the shadow and highlight detail of a negative will be less well separated if they fall, respectively, onto the toe and shoulder of the film's curve.

We normally control the toe of the negative through film exposure, by making sure that we give the film enough exposure to place the darkest values of the scene, that we want to see in the print, at the correct place on the curve. The shoulder is

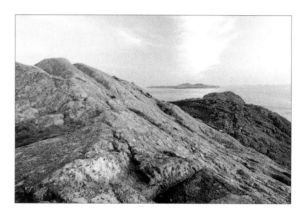

Split-grading the same negative, here by dividing the print exposure evenly between grade 3$^1/_2$ and then grade 1, has produced better separated shadows than the straight exposure version (see RAMSAY SOUND for more information on this image).

controlled through film development. Even if the film is properly exposed and correctly developed, there is still benefit to be had from split-grading the print. Also, it helps to remember that faster, higher ISO films have inherently more base fog which tends to mask any delicate shadow detail in the negative. Correct negative exposure and split-grading, using a harder grade setting for part of the print exposure, helps to overcome this problem. It also helps for under-exposed, push-processed negatives with less shadow detail, more base-fog and denser highlights.

Printing-in the highlights at a softer grade, either by split-grading the basic exposure or by burning them in separately, also helps to suppress negative granularity. One problem with enlarging 35mm negatives, particularly up to 20x16", is the tendency

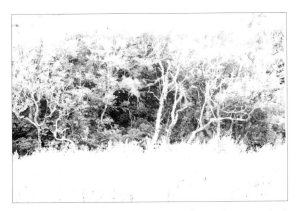

The Gribbin. Split-grading the print, first using a grade 4 filter to separate the shadow values, before making the second exposure at grade 1. If using grade 3¹/₂ or above, it is important to remember to double the exposure time unless using a Multigrade-type head.

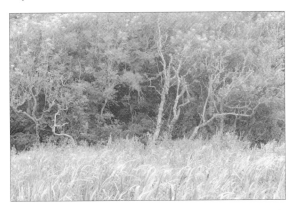

The grade 1 exposure on its own. When split-grading, it makes no difference whether the hard or soft exposure is made first.

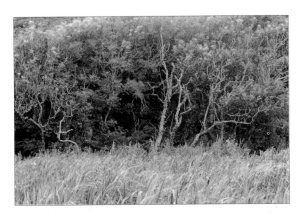

The end result before the print was locally burned-in with a grade 0 filter to tone down some of the bright highlights (see the printing diagrams of The Gribbin). Not every print benefits from split-grading. A simple test-strip should indicate if it is beneficial.

for the highlights to look excessively grainy and blocked up - these being the densest parts of the negative where there is the greatest amount of developed silver. In some cases, such prints can look as if they have been made from two different negatives, with the more detailed foreground of the landscape hiding almost all of the grain. This unpleasant effect can be very distracting and detrimental to the success of the print. With split-grading this isn't such a problem and even less of one if we use XP2 dye film. The less visible the grain the darker we can print the highlights and the richer (or "the creamier", to quote one writer) they can be made to look. Split-grading also helps to deal with badly exposed negatives and in particular, in landscape work, with inadequately camera-filtered negatives.

Knowing when and how much to split-grade is best determined in the usual way through test-strips. First make a normal test-strip of the correct exposure and at the right grade. If this was at grade 2, make another, perhaps starting with 50% of the exposure at grade 4 and 50% at grade 1. Develop it for the same time and note the difference. Try another, perhaps at grade 5 and grade 1, then another perhaps with 25% of the exposure at grade 5 and 75% at grade 1. You might even want to try using the very softest grade 0 setting. Make a whole series of these strips, that cover the darkest and lightest parts of the image to see exactly what is happening to the shadows and highlights. Remember to double your grade 4 (and above) exposure times when split-grading. Incidentally, it makes no visible difference which grade is used first.

Local split-grading, to burn-in specific areas, is something I do to almost every print. Sometimes I simply burn-in all the print edges (as mentioned in the introduction to DODGING AND BURNING), often at a softer contrast setting to tone them down without them blocking up or looking too heavy. Quite often I print the sky, or various parts of the sky, at a harder grade setting, perhaps to accentuate some cloud detail, and then perhaps I might print-in any bright highlight areas at a softer setting to tone them down in a less noticeable way. Sometimes I even bleach the print briefly to further lift highlight detail that has been printed in at a hard grade setting.

Whenever I do this work, I use the minimum amount of safelighting so that I can see <u>exactly</u> what I'm doing to the print, especially when burning-in dense, hard to see parts of the negative. Split-grading is useful for all subjects, e.g., a soft grade setting can be used on unsightly areas of skin, for example the tip of a nose. on portrait work.

Flashing and fogging

Print highlight control - techniques - an aid to split-toning

There aren't many times when I like to see harsh areas of white in a print. Without tone or detail they can make the eye search for information, trying to guess what should in fact be there.

More often than not we can deal with such areas by burning them in, perhaps at different VC grade settings, but sometimes, if the negative is particularly dense, some extra help, in the form of flashing or fogging, may be needed. I use both techniques quite often: to add extra highlight detail, and more silver for chemical toners to work on, i.e. those toners that work upon the silver of an image rather than upon just the gelatin of the paper.

Flashing is a much under-used, but once commonplace method of print exposure. Quite simply it involves exposing the paper to light but without a negative in the enlarger. Its effect is greatest on the lightest, least exposed parts of the print. How it works is simple. Imagine, that for our exposed print, the shadows have received 10 units of exposure and some bright highlights, which show no visible print density, have received just 1 unit. Then, if it takes a total of 2 units of exposure to render visible an area of the print, if we flash the print for an equivalent of 1 extra unit we will make those highlights visible, by carrying them over this 2 exposure units exposure-development threshold. Whilst this extra 1 unit of exposure effectively doubles the exposure of the highlights, greatly enhancing their density, proprotionately it will have very little effect on the 10 units of exposure given to the shadows and only a moderate effect on the lesser exposed mid-tones.

When flashing a paper, any very dense areas of the negative, that should always remain white in the print, such as the disc of the sun, will not be affected, since these parts of the print will likely have received 0 units of exposure prior to flashing. So, it should be said that flashing on its own, may not 'bring-in' all the highlights. As a technique, it is often used as an aid to burning-in, significantly reducing burning-in exposure times.

Fogging, on the other hand, will not leave as base-white any part of the exposed paper, since it involves giving the paper at least 2 units of extra

This is not a good example of how to make a flashing test-strip. My initial exposure of 3 seconds was too much; it has fogged the paper. This test-strip and the one below were made at grade 2. A harder grade test-strip would show a greater density change for each strip.

This is a much better flasing test-strip, made with a shorter initial exposure time of 2 seconds, with +1/4 stop for each subsequent strip. So the exposure sequence goes: 2, +.4 seconds, +.4, +.6, +.6, +.8, +.9, +1.0 and + 1.3. 2.4 seconds represents our maximum flash, 2.8 represents fogging.

Some people may be familiar with the terms 'pre-flashing' and 'post flashing'. They are used to describe flashing of the paper 'pre' print exposure or 'post' print exposure. In theory, pre-flashing is said to have the greatest effect, since it 'activates' the silver halides, making them more responsive to the print exposure. However, in practice, densitometric tests I have made indicate no measureable difference.

A technique I have seen some people use is to pre-flash a batch of paper, put it back into the box and use it later. Due to latent image instability, the effect of this exposure will begin to wear off after a day or two, so my advice would be to flash only those sheets you expect to use during that printing session. Besides, this technique was more applicable to the days of graded paper, when a half grade difference was not available. Nowadays, with VC paper we can flash and, or, split-grade the print.

This is a straight exposure print of Gwaun - 2, without any flashing or burning-in. Note the bright, white highlights, particularly at the top of the left-hand tree-trunk and to the top right.

For this print I reduced my basic exposure time by $^1/_4$ stop (e.g. 10 seconds became 8.4). Then I gave the maximum flashing time of 2.4 seconds (see opposite). Other batches and makes of paper will require re-testing to determine their maximum flash time.

Still at the same VC grade setting, this print had a 10 second basic exposure, followed by a 3.4 second fogging exposure to the top right of the print, to darken just that area. Using a pre-cut mask, I could also have flashed or fogged the bright highlight on the tree-trunk.

exposure. I would only recommend fogging prints to be toned, when the veiled (fogged) highlights will look brighter through their change of colour and the effect of colour contrast when split-toned (i.e. just the highlights are toned, leaving the mid-tones and shadows as shades of grey and black).

Both flashing and fogging can be applied to the whole or part of the print. If just part of the print is exposed in this way, because we have no negative to guide us, we need to cut out a card mask to ensure the light falls only where intended. We can stick pieces of white tape to the easel blades, opposite to where we need to hold the mask, to act as printing guides.

Unlike graded paper, we can flash and fog at different grade settings. Most usually I will flash at a softer grade setting to introduce more delicate highlight tonal values and to suppress any grain there. The skill with fogging is knowing how much we can expose the paper before the image really begins to look degraded. Generally speaking, for most toning work, I will fog the print for $+^1/_3$ stop above the maximum flashing exposure. This produces a light grey tone (which for Zone System workers equates to about zone 8), providing an adequate amount of silver for the toner to work on.

A flashing test-strip sheet will tell us our flashing and fogging times. To make one, put the enlarger head right up, throw the lens out of focus (to give the maximum light coverage), close the lens right down and start by exposing a blank sheet for 2 seconds. Then give $+^1/_4$ stop exposures for each additional strip, marking the edge of each with a pencil as you go. Once developed, the first visible strip we can see represents fogging, the one previous represents the maximum flashing time for that batch of paper. Different papers and paper batches will require testing to determine their maximum flashing time.

As a general rule, if a print needs flashing, make a test-strip of that negative as normal - to determine the right grade and exposure time - then take - $^1/_4$ stop off the print exposure time and flash for the required time. A print doesn't have to be given the full maximum flashing time if only a subtle change is required. It shouldn't be necessary to change grades when flashing a paper, but an increase of +1 grade may be needed if the print is to be fogged overall.

It isn't always convenient to take the negative out of the enlarger to flash a paper, especially if several prints are to be made from that negative. I have an old spare enlarger which is set-up just for flashing and contact printing. Alternatively, a very weak lamp above an unobstructed work-surface can be used provided the exposure time can be well controlled.

Special effects

Camera diffusion - enlarger diffusion - black borders - lith effects

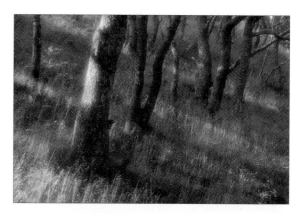

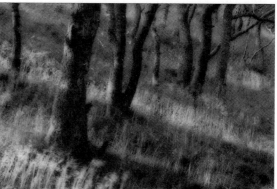

Note the difference between these images: the top one was diffused in camera, the lower one in printing.

Sometimes, in the search for a truly expressive print, it can prove helpful to use various printing techniques that go beyond the norm. Such techniques can be used to add emphasis, or they can even usefully de-emphasise unwanted details.

Diffusion is a technique I employ quite often for both these reasons. For example, because it bleeds one area into another, it can make easier the burning-in of difficult to print areas: bright skies can be seemlessly blended into foregrounds. I have also used it to get rid of detail, in particular those images where the camera has been held near to ground level with a wide-angle lens. Such a low viewpoint can give unwanted prominence to foreground information, when maybe the emphasis of the image has been on a greater sense of perspective, or depth, as emphasised by the choice of lens.

Unlike camera diffusion, enlarger diffusion makes the darkest parts of the image bleed out into the mid-tones. Shadows, rather than bright highlights, gain greater prominence. (I have even used diffusion both in camera and in print for added effect.) And like camera diffusion, it is important not to overdo the effect. Too much enlarger diffusion can lead to muddy looking prints, especially in portrait work, where skin tones can begin to look a little too grey and lifeless. In particular, enlarger diffusion is good at enhancing silhouetted images.

How do I diffuse my images? The simplest way I have found is to use the glass from a 6x6cm anti-Newton transparency mount fitted into an old under-the-lens VC filter holder. This diffuser can be used below the lens for all or part of the exposure time. Stronger diffusers can be made by using two sheets of glass. A test-strip will show how much extra print exposure is needed to compensate for the light-stopping, image scattering effect of the diffuser and this will provide a filter exposure compensation factor for it (like those for camera filters). Other diffuser materials include black stocking, although like polythene, another good diffuser, it needs to be held evenly tensioned under the lens for a uniform result.

Local diffusion is another useful tool, perhaps for softening highlights as they are burned-in. Partial diffusion of the image, say for 40% of the basic exposure time, is also a good way of suppressing print graininess without affecting print sharpness too much. Also, split-grade diffusion is possible, e.g. we can diffuse the higher contrast part of the exposure to make those darker areas more prominent.

Black borders are a popular technique. Either they can be made with a manufacturer's over-size negative carrier, or by filing out a neg carrier to leave part of the negative rebate visible. This filing work should be done carefully, because of the high degree of image magnification during enlargement. If too much of the film rebate is visible, 35mm sprocket holes, which refract light, will locally fog the print, e.g. the photo of Ramsay Sound. Also, the raised edges of some easels may reflect this light to create a dark, unwanted band along the print margin.

Other special effects are covered elsewhere, they include local flashing, local fogging and local development. Lith printing, using a high contrast lith developer to get a split-tone effect, does not seem to work well with VC papers. However, the effect it gives, of high contrast shadows with compressed mid-tones and highlights, can be achieved using split-grading with VC's. Its split-tone colour can also be achieved quite simply, by partially toning the print with a vari-sepia thiocarbamide toner.

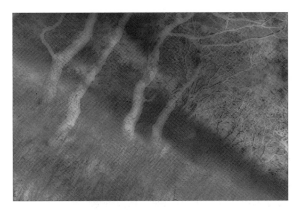

Gwaun - 1. This negative was metered normally, but the camera's centre-weighted meter was in fact misled by the back-lit nature of the scene. As a result, the negative is under-exposed.

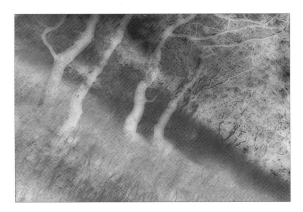

This negative is 'correctly' exposed by normal standards. It would produce a perfectly good print, but not one with as much shadow detail as the cover picture, which was made from the negative below.

Two stops more exposure than the centre-weighted meter reading has given a very detailed negative with excellent shadow separation. Had this negative been made on conventional film, development would need to be shortened to prevent the highlights blocking-up.

Negative quality

XP2 negative film - bracketing exposures - working with 35mm film

The type of negative required for VC printing is no different to that which is best suited to graded paper. There are many books that tell us in great detail about the theoretical qualities of such negatives and how they can be made through conventional means of exposure and development control. So, by way of a contrast, I decided to make all the photographs for this book on 35mm, using Ilford's XP2 chromogenic, dye-negative film. Like VC paper, I felt its creative potential has been largely ignored.

The fineness of grain of this ISO 400 dye film, especially when it is down-rated to ISO 200 or even ISO 100, coupled to its exposure latitude, is extraordinary. It is capable of holding very bright highlight and dark shadow detail on the same frame, without changing development. It is the closest 35mm users can get to Zone System photography. For subjects of extreme brightness range, increased film exposure (say, +1 or even +2 stops) renders visible more shadow detail, yet the dye (i.e. more translucent than conventional silver) highlights remain printable <u>and</u> they possess even finer grain - i.e. the opposite of normal silver image b&w negatives. This is particularly useful. For example, the most heavily exposed, densest part of the negative is normally the sky. Usually, it is the least detailed, least grain-masking part of the image, so it shows up <u>silver negative</u> granularity the most - just where we don't want it.

I bracketed all my camera exposures in +1 stop increments (up to +2 stops). I also covered myself for any exposure errors by bracketing in this way (e.g. the negatives of Gwaun - 1, opposite).

All the films were C41, lab processed, the same as for colour negative film. With XP2 there is little need to consider an alternative developer, unless we wish to produce a silver image. I hope my prints clearly illustrate just how (unnecessarily?) caught up we can become trying to produce the traditional 'perfect negative', using conventional means, when our time might be better spent being 'creative' in other ways, i.e. through camera and printing techniques.

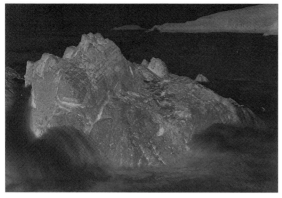

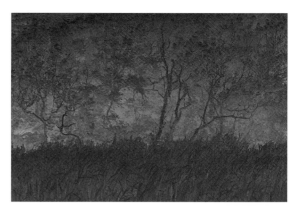

Featured on the next three pages are the negatives used to make all the toned images of this book. They have all been made on XP2, rated at a variety of ISO setings (ISO 400 down to ISO 100) and C41 developed, without modification. This is the negative for Non's Bay.

The Gribbin.

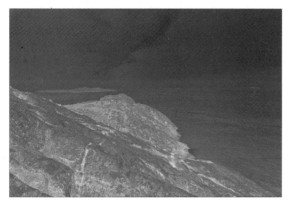

Ramsay Sound.

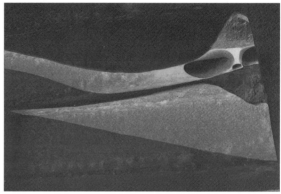

Wreck - 1.

However, it does take a little while getting used to XP2. It needs more gentle camera filtration, to avoid an over-exaggerated effect, which is definitely no bad thing. For example, a red filter is rarely necessary. Assessing negative quality also takes a little practice as the film has a slight magenta-ish colour and its density can, at first, seem a little hard to judge, being a dye rather than a silver image. Incidentally, the colour of the negative doesn't affect the contrast of VC papers.

What negative is best is a personal choice, but several years of printing for others taught me a lot. Too many negatives need contact printing on grade 3 or 4 and then require grade 5+ when enlarged - a far from ideal, even impossible situation. I like my negatives to look good contacted on grade 1 paper or softer. That way they will print up well on grade 2, giving me the option to print harder or softer.

As a final note, fine-grain negatives are usually easier to print, since the print can be made darker, to look richer in quality, without it looking heavy and without resort to a harder grade.

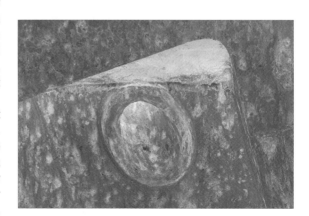

Wreck - 2.

84

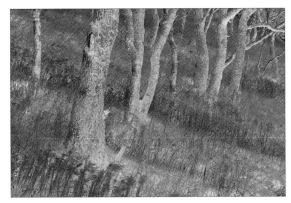

Pontfaen.

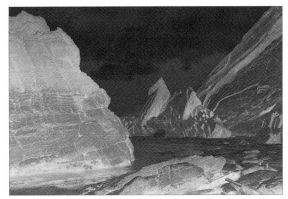

Cradle Bay.

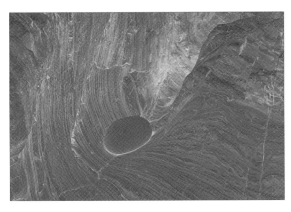

Solva Bay.

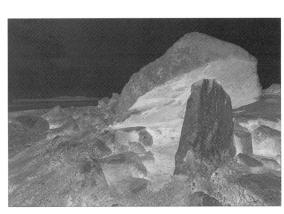

St. David's Head.

Gwaun - 2.

Wreck - 3.

Test-strips

Guides to print exposure, contrast and print manipulation - towards a printing plan

There are few better aids to VC printing than the humble test-strip. I rarely, if ever, make a proof print without one and never make a final print without making at least two or more. They provide useful exposure information on all kinds.

To be of most use, the test-strip is best laid across the darkest and lightest parts of the enlarged negative. A rough starting point for the print exposure and grade setting can be achieved by first viewing the negative on a light-table against one of similar contrast and density that has been printed previously. Experience and the printing notes for that image provide a useful starting point for the print exposure time and the grade setting required. I'll expose this first test-strip, increasing each band of its exposure in $+1/4$ stop increments - working out these additional exposure times using an f.stop table, such as that on pages 102-103..

For a 20"x16" print I normally use a piece of paper about 20"x3" in size, making sure it covers the most exposure-sensitive parts of the image. It is expensive and unnecessary to use anything bigger. After I have exposed and developed the strip for the normal development factor, and put it through the stop-bath and fixer, I'll evaluate it under the print viewing light, having rinsed it and wiped it free of surplus water.

For a simple print, that we don't want to manipulate, I would look for the strip which appears to have the right exposure for the highlights. If this strip of exposure has the right density and contrast in the darkest shadows then fine, it means no grade change needs to be made. The print can then be made at the same exposure and contrast setting. If however, the shadows are too heavy or too weak, then we need to reduce or increase contrast respectively. Normally I would make another strip at the revised contrast setting, using the same exposure time. In theory, no modification of exposure should be required, except if we need to go to grade 4 or above, since the speed of the paper is the same for grades 0-3$1/2$.

However, in practice, I have often found it necessary to increase print exposure times slightly

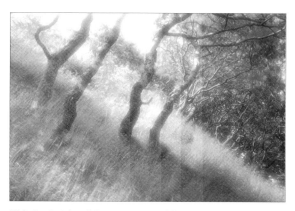

This test-strip of Gwaun - 1 provides only the most basic exposure information. From it we can only determine the right basic exposure time for the print and a little of how much the right-hand side needs to be burned-in.

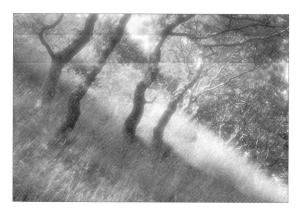

This test-strip is not much better. Again it gives us the basic print exposure time, plus some indication of how much extra exposure the sky needs. A better test-strip would be a combination of this and the strip above, rather like that below.

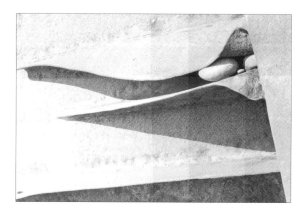

This test-strip of Wreck - 1 gives us virtually all the print exposure information we need in one test-strip. The first strip represents -$1/2$ stop, the second = -$1/4$ and the fourth strip +$1/4$. The top strip = +$1/2$. This test-strip gives us our dodging <u>and</u> burning-in times.

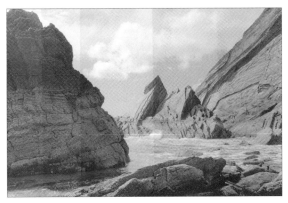

The third strip from the left is the basic exposure time. The second represents -$^1/_4$ stop, (i.e. how it would look if we dodged it by -$^1/_4$ stop). The first strip = -$^1/_2$. The fourth and fifth strips = +$^1/_4$ and +$^1/_2$ stop. They show how much the right-hand side can be burned-in.

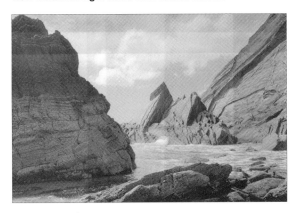

This grade 2$^1/_2$ test-strip has been made the same as that above, but with +$^1/_4$ and +$^1/_2$ stop for the sky exposed at grade $^1/_2$. Note how the sky has darkened, but, with this lower contrast setting, the upper left of the rock has not darkened too much.

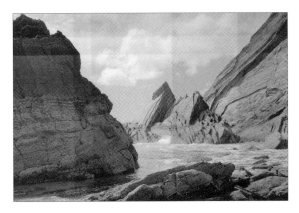

As above, but with a grade 4 filter for the sky, so that the clouds look better separated. Notice how the extra exposure at this hard grade setting has made the top of the left rock go too dark and heavy. Either this requires dodging the rock or more care burning-in the sky.

for higher grades of a paper, if I wish to retain the same amount of highlight detail.

For creative printing, with print manipulation, I will make another test-strip with less exposure, perhaps -$^1/_3$ stop, to show what will happen if I dodge any areas. In my experience, for a well exposed negative, with plenty of shadow detail, this is about as much as we can hope to dodge an area without it looking very weak, with blacks that have turned to grey. It should go without saying, that if there is little detail visible in an area to be dodged then even -$^1/_3$ stop will be too much, unless it is dodged for longer and partially burned-in again at a higher contrast setting (as discussed in BURNING AND DODGING).

Another, test-strip at perhaps +1 stop exposure, will tell me how much I need to burn-in brighter highlights (my initial test-strip should give me a rough indication as to how much extra exposure might be needed). For particularly dense highlights, I will make test-strips at +2 stops or more, laying them across these densest parts of the negative. After that, I might even make some strips at different grade settings, with different exposures, to show me, for example, what the sky of a landscape might look like if I burned it in a harder or softer grade setting. Then I might also make some split-grade strips, to see if there is any benefit from changing the tonal range of the print. I'll pencil-mark them for reference and develop them to the same factor.

Once they are fixed and briefly rinsed, I'll wipe them free of surplus water and lay them out on a white dish; anything coloured confuses the eye.

This may sound like a long-winded approach to making a print but it should use up no more than one sheet of printing paper, which will work out far cheaper than throwing whole sheets at the easel in the hope that one might come out right. I have learnt more about printing from making test-strips in this way than from guessing how much dodging or burning-in an image might need.

Working from the test-strips, I'll make a printing plan, then I'll wash them and keep them for reference purposes later. They provide a useful visual diary of how I've made my prints, subsequently providing a clear indication of not only how I made the print, but, just as useful, indicating where I might have gone wrong, should the print not look right.

An extra test-strip, briefly rinsed and rapidly heat-dried (in an old flat-bed drier for FB's), also shows how much the print will dry down. Upon inspection, if thought necessary, the basic print exposure and all dodging and burning-in exposures can then be modified accordingly.

Print exposure control

Printing to a plan - f.stop system - effect of different materials - negative quality

Careful exposure control shouldn't end once we have exposed our film, and yet much printing work is haphazard, based on guesswork. Why not adopt a more logical approach? The only reason why not, that I can think of, is that maybe it would deprive us of that sense of excited anticipation, of not knowing what the print will look like, of expectantly watching it as it emerges in the developer under the safelight.

Why not think about how the print should look before we expose it? Why not develop a system of exposure that gives us the results we intended when we saw the view and saw our view of it in camera? It makes sense. Besides, simply going by the appearance of the print under the safelight is a poor indicator of how it will look in normal daylight, i.e. less contrasty, darker and more detailed, often revealing detail that maybe we don't want to see.

The system of exposure control that I use is the same as for camerawork, that is I work in f.stops. It is very simple and gives infinitely more predictable results than most other supposed systems, especially when combined with the use of test-strips and printing diagrams. That said, if the 'system' you use works, and you're happy with it, why change?

Like other methods, with the f.stop method, the basic print exposure time is worked out in seconds, determined by making a test-strip (see: 86-87), which is the darkroom's equivalent of the camera meter. Once this time has been ascertained, then any other exposures, such as dodging or burning-in, are worked out in f.stops and fractions of f.stops, by making a series of + and - f.stop exposure test-strips, perhaps in + and -$1/_4$ and $1/_2$ stop increments. The exposure times needed for these + and - strips are simply obtained by using an f.stop exposure table or with an f.stop timer (at last there is a sensibly priced model on the market).

Working in this way we can very quickly begin to learn to anticipate the difference that various + and - f.stop exposures will make to the density of prints of all sizes. The same cannot be said of working with the normal ordinal system of exposure, timed entirely in seconds. For example, + $1/_2$ stop of exposure, to burn-in a sky, will have the same effect on a print requiring a basic exposure time of 10 seconds (i.e. + 4.1 seconds) as on a larger print requiring a basic exposure time of 20 seconds (i.e. +8.3 seconds).

The success of this system, like all print exposure systems, also depends on understanding the materials with which we are working. For example, we know that unless development is modified, +1 stop of camera exposure doesn't have the same effect on the density of negative highlights for films of different ISO numbers, because films of a lower ISO are inherently more contrasty. Similarly, +1 stop in print exposure will not have the same effect on papers of different contrast grades. For example, +$1/_2$ stop exposure to a grade 1 print will render visible the same amount of extra highlight detail as +$1/_2$ stop for a grade 3 print, since they have the same speed. But, because the latter is more contrasty, +$1/_2$ stop will have a greater effect on the density of the darker grade 3 shadow areas.

We have to learn how to visualise such differences, most easily by making a series of + and - exposure reference proof prints for the various grades using our chosen make of paper. Different surfaces of the same make and different makes will all produce different results. Gloss paper and the lower contrast grades have the most latitude. They are also the most tolerant and easiest to work with.

Another important aspect of exposure control is working with a manageable basic exposure time. I have watched too many photographers trying to dodge prints of a ridiculously short basic exposure time. Better to work with a minimum basic exposure time of at least 10 seconds (see: DODGING AND BURNING).

And of course, an important part of VC print exposure control involves being able to read the negative first, to see what is possible. Too often we try to make prints from unsuitable negatives, usually with insufficient shadow detail. It is good practice, before printing a negative, to compare it to another of similar quality and check it against the printing plan for that negative. We should then ask ourselves if we want to make a 'straight' print, using a grade of paper that fits the range of the negative: exposing the paper for the highlights and choosing the right grade to get the right amount of density in the shadows. Or do we go for something a bit livelier and choose a harder grade, expose it for the shadows and burn-in the highlights? Or do we choose a harder grade, expose it for the mid-tones, dodge the shadows and burn-in the highlights? (see: TEST-STRIPS.) And, of course, there is the option with VC paper to use different grades as well, to further alter the tonal range of the print.

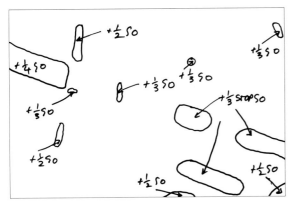

This plan for Pontfaen has been mapped out in f.stops, as for all the diagrams in the book. I make my plans by laying tracing paper over proof prints, so that I can map out exactly which areas of the print I have modified..

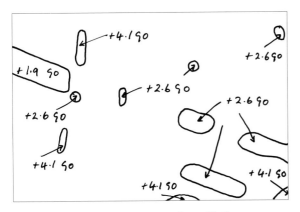

This is the same plan as above, but with the exposure times in seconds, based on a 10 second basic exposure. Remember to double any exposure times when working above grade 3¹/₂, unless you are working with an exposure compensating Multigrade-type lightsource.

My first plan usually shows the basic exposure and any dodging. I note the grade needed, the size of the print and the f.stop I have used. I will also note the enlarger lightsource, the paper type and its batch number.
My second plan usually shows any burning-in that needs to be made at the same grade setting, whilst a third diagram usually shows any burning-in at other grades. If I burn-in at two different grades, for example a soft grade for any bright highlights and a hard grade to separate cloud detail, then I'll make separate plans for each of these. I record any flashing or fogging exposures on a separate diagram and any local bleaching work on another plan. I also record all relevant toning information, such as which solutions were used, how much the print was bleached, water temperature and wash times. This might sound involved, but plans such as these are surprisingly quick and easy to make.

Printing to a plan

Guesswork - printing by numbers - repeatable print making

It is quite possible to print an image 'freehand', without making any sort of proof print to guide us, but better I have found to first make test-strips and from these a printing plan. For me, the excitement of b&w is not the anticipation of waiting to see what comes up in the developing dish, but seeing it come up as planned. I like to see my image in the dish, not one that is the product of guessed exposures cast onto a piece of paper, perhaps at random.

Good printing is closely allied with the right state of mind. I'll print only when I am in the mood. Most of us apply the same principle to our camerawork, but often look upon printing as something that "has to be done", often reluctantly, whenever it is necessary. So, even with a plan drawn up on paper, that gives the exposure and contrast grade(s) information, I still won't print the image unless I feel ready.

My printing plans are simple illustrations of how the print needs to be exposed, where it needs extra or less exposure, and where these will benefit from contrast changes. I draw them from the various test-strips and any proofs I have made. I keep in mind my original pre-visualised image, but if I notice a way of improving upon it I will modify the plan accordingly. Part of the pleasure of photography is the ability to reinterpret an image; some would say that making the image is not the end of the process but the start of it - continuous reinterpretation completes the picture.

The idea of the plan is to be able to print the picture 'by numbers'. For complicated multiple exposure prints I tick-off each exposure as it is made so that I don't repeat any. Once the print has been processed and evaluated, I'll modify my plan where necessary. I pencil-mark each print I make for identification purposes. For example, I may keep print no. 1 as b&w, whilst print no. 2 might be used for testing the toner. Prints no. 3 or 4 might be good final images, but very often it is not until print no. 5 or 6 that I get near to what I'm after.

Printing plans make the process repeatable. Also, they enable me to improve upon any prints that don't quite look right and to apply the knowledge gained to subsequent prints.

Print balance

Camera composition - cropping - effect of toning - viewing methods - dry-down

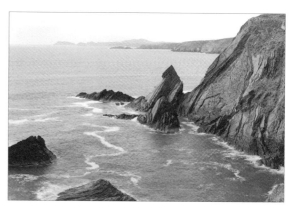

A straight exposure print. Without camera filtration this version is not helped by the distracting lines of froth, nor by the overly bright sky. It is clearly very out of balance - a combination of poor camerawork and bad printing.

Camera composition and print balance are synonymous. They go hand in hand. One can't function without the other. A good print is a combination of creativity and consideration, of camerawork and printing. Can we separate the two? Can we carefully compose our images in camera but leave the balance of the VC print to the way the film recorded the scene? Similarly, can we lavish attention on our prints without really having a good image to work on? I think not.

It is hard to explain print balance. Sometimes the best I can do is merely to say when a finished print "feels right". Beyond that it can be difficult to put into words what it is that I believe makes a particular image work: see what's good for one print and very often I'll try to do the opposite for the next. I sometimes think that good print balance is knowing when to break the rules, by introducing that element of surprise and tension into a picture. Create rules of balance and what we're doing is presenting ourselves with the opportunity to break them. Black shouldn't always compliment white; sometimes the best print relies entirely on shades of grey, e.g. The Gribbin.

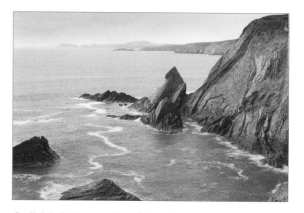

A slightly better version of that above, but the burned-in sky looks rather obvious and contrived. However, the image is better balanced in that the eye doesn't stray quite so much up to the top left.

There are those landscape prints which rely on a natural order of shapes and tones. Yet to balance such images in printing still requires a degree of interpretation: skies may benefit from darkening down, perhaps at a harder VC grade setting, edges may need burning-in, to emphasise the framed nature of the photographic image, and so on.

The best way to start is to ask ourselves "what will make the image look the way I intended". At least, if this draws a blank, it will emphasise the lack of thought that went into the image in camera. If it raises doubt then maybe we have not been decisive enough with our camerawork. Sometimes the crop of the image may not be tight enough so that there may be images within images. Print balance doesn't always mean printing full-frame. There are times when I'm more than happy to crop a negative, to admit that I made mistakes in camera, that maybe I saw something which I didn't identify clearly enough with my camerawork. Very often this is true with my

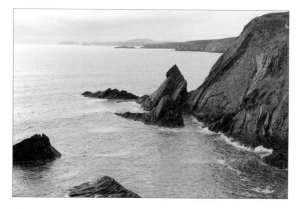

Camera polarisation has worked to make a better print of this scene, without burning-in or dodging. Note the absence of the froth and the natural look of the sky. This version looks well balanced and paves the way for some image enhancing creative VC printing techniques.

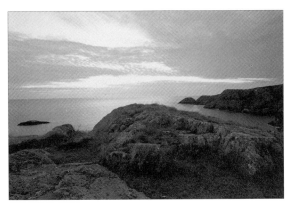

All the ingredients are here but the picture really doesn't work. The right-hand side is too heavy. In this case it is a problem that can only be solved by better camera composition. VC printing can be used to salvage certain images, but not this unbalanced image.

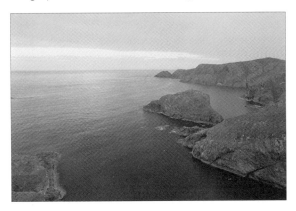

This image is a little better balanced, but the bright line of cloud appears to unnaturally dip down to the right. This can't be easily corrected in printing unless we are happy to accept an unlevel horizon. Natural cloud formations like this may look good to the eye but do they necessarily make good photographs? If not, should we even bother trying to print the negative?

35mm images: the rectangular format seems to draw in all sorts of unwanted elements into the photograph. Too often I find it a most irregular shape with which to work.

Important to any print making is not to let the viewer do all the work. Through careful balance we help the viewer to see our image more clearly, but does this have to be in an obvious way? Does good print balance have to point the finger at the subject?

When I'm making a print to be toned very often its balance won't look right in b&w until the application of colour. Very often the highlights may appear too heavy, giving the print a top-heavy feel. This is particularly true of images to be split-toned, most usually with vari-sepia toners, to put colour just into the highlights. Split-toning warm-tone papers with selenium toner, that puts colour and added density into the shadows, doesn't require the same attention to balance other than making sure the print isn't so contrasty that the shadow detail subsequently blocks up. However, the introduction of colour into b&w printing can change the look of an image as dramatically as converting the original colour scene into b&w - as seen by the colour transparencies, proof prints and finished images in the first section of the book.

There are a number of useful aids for checking print balance. First I tend to put the briefly washed print on the sink splashback. There I wipe off the excess water with a rubber blade and then, sitting about 4 or 5 feet away from the print, I will stare through the middle of it, focusing on infinity. Viewed in this way, the print becomes blurred. For a start, if an edge is too light it will disappear from view, blending into the white print margin. Focus on the print and the image edge may appear visible again, more so as one steps closer. This is a good indicator that the edge hasn't received enough exposure. Likewise, areas that are too dark will gain unwanted prominence as the print is viewed in this way. Focusing on the image allows the eye too much control, to search for detail when maybe it isn't really prominent enough. If in doubt, cover up the area in question, perhaps with a piece of neutral grey card or simply with your hand, and try to imagine what should be there underneath. Take the card away and if the area isn't correctly balanced it will jar the eye straight away. Practising this with other peoples' images is a good way of learning how to balance an image. We can't expect to learn it all from our own efforts.

Print balance also has a lot to do with how certain papers dry-down. When wet, added prominence is given to shadows whilst highlights look brighter. As the print dries everything slides down the tonal scale, but it won't all slide down at the same rate. For example, non-glossy surfaces will show a distinct change in relative values, most noticeably in the darkest areas of the print.

When printing, think ahead: try to visualise the dry print. Also try to think how print size effects balance. How the picture is to be presented will also add weight to the image, perhaps in an undesirable way, for example by using coloured or toned mount board. Against an off-white card, a faint area of detail in the print will appear relatively brighter; print edges are easily lost in this way. I tend to leave a margin of paper-base white between the image and the mount to allow the image to define its own edge.

Development controls

Developing a method - emergence times - the Factoral method

VC papers don't necessarily require a special developer. Their emulsions are like other print emulsions: composed of silver suspended in a layer of gelatin. And yet, like graded papers, to get the very best image quality, or the widest range of creative effects, it does pay to understand even a little of the development process and to see how it affects different types of VC paper. In particular, it pays to use different developers to get the broadest range of image colours with the warm-tone chloro-bromide VC's, i.e. the Agfa, Forte and Sterling papers.

Working with VC papers we have the means to control print contrast and tonality through the right choice of grade, or half grade, and by split-grading and flashing techniques. So, in theory, there should be little need to alter our development routine, as is often the case with graded papers, to get half grade changes in print contrast or subtle alterations of tonality. What is important is to establish a development routine. For me, this means using the same type of developer, usually Ilford Multigrade, at the same dilution and temperature, making sure it is fresh and not old (oxidised) stock and using the Factoral system of development.

The Factoral system is quite simple. I use it to guarantee consistency during the session. Using it, we note the emergence time (how long it takes for the VC print to appear in the developer) and then we multiply this time by an appropriate factor to give us our total development time. The choice of factor depends on a number of options, primarily based on VC emulsion type and whether we want to alter D-max, contrast, tonality and image colour. Working with Multigrade FB I usually opt for a factor of 6 which, based on an average 30 second emergence time at 20C, gives me a total development time of 180 seconds. Emergence times vary from between 15-30 seconds for different makes of paper.

As a general rule, small factors of 2 or 3 reduce print contrast, compress the tonal range, lower D-max and warm-up the image colour. A factor of 4 or 5 is considered normal, whilst extending development time to give a factor of 10, or sometimes more, can increase contrast, possibly raise D-max a little and expand the tonal range, whilst also cooling-off image colour. Smaller factors require more print exposure, larger factors less. A factor of 5 or 6 takes most VC papers near to completion, i.e. they won't develop much further to provide any significant changes in density, although VC FB papers usually respond better than RC's.

Small factors require very quick and even immersion of the print into the developer, plus extremely good agitation to minimise any unevenness of tone which may become especially apparent if the image is later bleached or toned. Larger factors require very careful safelight control when working with VC's, to eliminate any fogging; they should also be checked for chemical fogging, i.e. the unwanted development of unexposed silver due to prolonged development. This is done by comparing the white unexposed print margin with the white of a normally developed or undeveloped and fixed piece of paper.

All VC's will show changes of contrast, density and tonality if their development factors are altered, but only the warm-tone chloro-bromide emulsions will show a significant change of image colour. If we then use a warm-tone developer, like Agfa Neutol WA, we will get warmer results, and then if we use a smaller factor (about 3 is normally right), with an appropriate increase of print exposure, the image will appear even warmer. The use of a cold-tone developer, like Agfa's, and a larger factor, will significantly cool-off the image colour of these VC papers towards blue.

The Factoral system also takes into account any changes to a developer during the printing session. For example, if the developer gets colder, so that the image maybe takes 40 seconds instead of 30 to appear, we simply multiply 40 by our original factor (say x6) to get the new development time of 240 seconds. Likewise if the developer gets warmer and the emergence time shortens, we can work out the shorter overall development time. Changes in developer efficiency, seen as a longer than normal emergence time, can also be taken into account in the same way.

Other development controls include agitation. Less agitation can subtly reduce print contrast, whilst too little may, in fact, lead to unevenness of tone. However, unlike graded papers, I would recommend filtration control as a much better alternative. Excessive agitation speeds up development a little, ensures maximum contrast and tends to oxidise the developer more rapidly, creating extra chemical evaporation and a greater need for better ventilation. Developer temperature also affects

VC image quality: too cold a developer, especially 14C or below, reduces contrast, lowers D-max, slows development and cools-off image colour, and vice versa. Increasing the concentration of developer can increase D-max and contrast. If coupled to more print exposure and a shorter development time, it can also warm up image colour. Greater dilution and an extended development can extend the tonal range of the VC image, but, again, filtration control usually works better and doesn't involve changes to the development routine.

A higher contrast developer can increase VC print contrast a little. A popular method of development control with graded paper, which is worth a try with VC's, is to use two baths: one is a high contrast developer, the other a normal or lower contrast developer, with the development of the print being split between the two. Whichever bath the print enters first will have the greatest effect. Putting the print into a high contrast developer towards the end of development is sometimes done just to pick up the shadow values a little, giving the print a bit more lift. These techniques can help a VC print. Even water bath development can sometimes be worth a try.

As a general rule I work with no more than half an inch of developer in a dish. For a 20x16" dish this equates to 2 litres of developer. Too much developer prevents agitation of the dish without excessive spillage. I also use flat-bottomed dishes, or ones with grooves - not protruding ridges - to avoid marking (sometimes embossing) the print, whilst leaving a white unexposed margin around the print, of at least an inch, provides an image-free area to handle the print with tongs or gloves so that no possible staining appears in the picture.

For local control, hot or concentrated developer can be applied to specific parts of the print to darken them. If there is not too much developer in the dish, it can be tilted to expose the relevant part of the print for this local treatment, applied with a swab of cotton wool or a brush used solely for the job. Rubbing the surface of the print, to locally speed up development, may help but it can mark the print, often quite visibly after it has been toned, for example with selenium or thiocarbamide toner.

As a final note, some VC papers have developing agents incorporated into them, RC machine processing papers in particular. The inclusion of such a developing agent can restrict dish development control, although a one to two minute pre-soak in water at 20C, prior to development, can help to eliminate its effect.

Stopbath

Development control - acid or water variety - techniques

As for graded paper, VC print development needs to be arrested by a stopbath for several reasons, beneficial to making images of the highest quality.

Most importantly the stopbath curtails development so the print won't darken further before it is fixed. This is especially important if development is still continuing apace when a short x2 or x3 development factor is being used to compress the tonal range of the print or to warm up image colour. However, an overworked acid stop, or too concentrated an acid stop, may even cause a slight blueing-off of warm-tone prints.

Most stopbaths are acid, usually a 2-3% solution of acetic acid, citric acid or similar. Their acidity neutralises the alkalinity of the developer, which activates the development process. If we choose not to use an acid stopbath, perhaps because the fumes can sometimes be unpleasant, or because a plain or alkali fixer is being used, then a plain waterbath should be used. It should be replaced after a couple of prints at most or developer will be carried over into the fix and dichroic fog (staining) may result, not to mention incomplete fixing.

My own preference is for a plain 2% acetic acid stopbath. The yellow indicator variety, which turns purple when exhausted, tends to briefly discolour the print, making image assessment harder. I keep a note of how many prints have gone through the stopbath, or simpler still, use pH indicator papers to provide a cheap and easy means of checking the acidity of the bath.

The processing procedure I use is to first drain the print for 10-15 seconds over the developer dish, holding it by one corner so the solution runs off more freely. Then I immerse it evenly into the stop and agitate it continuously. VC RC prints need about 10-15 seconds, FB prints a little longer. I then drain the print for 10-15 seconds over the dish before putting it into the fixer. When using a plain water stopbath, I rinse the print for at least half a minute, or more, prior to fixing, making sure, as with any stopbath, to use tongs or gloves and to handle the print by its white margin only.

Fixing

The process - types - image permanency - techniques

Unlike development, print fixing is an invisible process. Its effects go unnoticed, and if improperly executed, its ill-effects may not become apparent until the print fails to tone properly, or later it might fade or change colour.

The fix works in two stages. First it makes soluble the unexposed and undeveloped silver salts in the VC emulsion, then it removes them into solution. (In fact, we can see the first clearing stage of this process with films.) The idea is to fix the image for double this clearing time. How long it takes to fix a print depends on the fixer: there are two types, rapid ammonium thiosulphate and traditional sodium thiosulphate, the former is about twice as fast and is used in Ilford Hypam and other, similar, "rapid" fixers. Fixing time will also depend on the age of the fixer and how many prints it has fixed, i.e. how much silver it holds in solution. Ideally, for maximum VC FB archival permanence, and for optimum toning results, there should be no more than 0.7g of silver per litre. We can measure this with silver estimating papers (rather like pH papers). About 20 10x8" prints per litre of working strength (correctly diluted) fixer is about right. After that, it can be used for FB proofs, then RC prints up to about 1.5-2.0 g/litre.

To improve fixer efficiency and to minimise the reabsorption of soluble silver into the paper base of VC FB's, two fixing baths are best. The print is fixed for half the time in each. Alternatively, we can use one bath of Hypam fixer, diluted 1+4, for 30 seconds, with constant agitation.

VC prints left to sit in the fixer, or stacked up in it, may stain, bleach where they sit proud of solution and may be incompletely fixed. Overfixing, to be on the safe side, is to be avoided. It increases washing times and can interfere with toning and image permanency. My preference is normally to use two baths of Ilford Hypam, diluted 1+9, (1 minute in each), and without the addition of a hardening agent which is not good for toning or archival processing.

Finally, it is a good idea not to switch the lights on for at least 15-30 seconds after immersion into the fixer, in case there is still active developer carried over in the print emulsion.

Bleaching

Applications - the process - effects - techniques

We can bleach a VC print to lighten it, or to change its tonal range and, or, to alter its image colour. Just as for toning and redevelopment, bleaching is done after fixing, following a brief wash, with the lights on.

The most common bleach is Farmer's reducer. It is a simple solution of potassium ferricyanide (the same bleach as that of sepia toners), combined with an appropriate amount of fixer to make the bleaching work permanent. Typically, I will add 3.00g of ferricyanide to 270.00ml of water, then add 30.00ml of stock Ilford Hypam fixer. (i.e. 300.00ml of working strength fixer, with 3.00g of ferricyanide added.) Without the addition of fixer, or the use of a separate fixing bath afterwards, the image will soon fade and discolour.

The Farmer's works first on the highlights, then the mid-tones (without affecting the blacks) and finally on the blacks themselves. Continued bleaching with it will change image colour, towards brown. This is not a stain, but rather like the recently reintroduced FSA redevelopment toner, it is the silver particles being altered in shape and in size.

Farmer's can be applied to the whole print, by immersing the image in a dish, or it can be applied locally with a brush, cotton bud or swab of cotton wool, avoiding brushes with bare metal ferrules. For local work, I always wipe the surface of the print free of excess water. Both RC and FB VC's respond well, although for local bleaching I prefer the more absorbent FB's that take up the solution where it is applied, preventing unwanted reduction of adjacent areas. A white border around the image, of at least an inch, prevents the edges of dish-bleached images from bleaching first where there is the greatest turbulence of solution as the dish is agitated.

It is a good idea to intermittently rinse the print with cold water during bleaching. It arrests the process, so the rate of progress can be checked. My own preference with dish bleaching is to combine the ferricyanide and the fixer into one solution to give a "what you see is what you get" result. Used later, the fixer bleaches the print slightly.

If prints are to be bleached when dry, perhaps to eliminate small dark marks, such as dust on the film

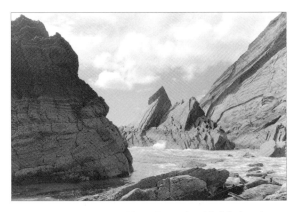

An unbleached print of The Cradle, made slightly darker than normal to prevent the highlights from becoming too bright after bleaching.

Toning

The need for it - the processes - visualising the toned image

The bleached image. Note how the highlights have lightened, with the shadows and mid-tones unchanged.

prior to camera exposure, then they should always be washed afterwards.

A technique I often use, to change the tonal range of the image and to give delicately separated shadows, with more pronounced but not overly white highlights, is to make a print about a $1/3$ stop darker than normal, and usually $1/2$ grade softer (to keep the shadows open), and then to bleach it until the highlights look right. I often use this technique in conjunction with split-grading techniques.

If a VC print is overexposed by +1, or + $11/2$ stops, and bleached-back, in a fairly dilute solution of Farmer's, the image can attain a sepia effect, with greatly pronounced tonal separation, especially on a micro level, as it accentuates the graininess of the image. For this effect, it may be necessary to print a grade softer, to prevent the over-exposed shadows from blocking up. Although the pre-bleached print will look very dark, holding it up against a light will reveal all the detail waiting to become visible.

Colour photography can be overly reliant on the absolute value of colour, or on the immediacy of colour contrast within a scene for the success of an image. The same can be said of some b&w toned images. Take away the colour and what is left? Does the image still work? Therefore what prints do we tone and why?

Toning can do more than just change image colour. It can change colour by subtle degrees. It can alter print contrast, tonality and density. D-max can be visibly increased with selenium and the recently reintroduced FSA sepia toner. Certain toners will improve image permanence: selenium, gold, sepia, sodium sulphide and poly-sulphide. Most toners work on the silver on the image, although some, most notably gelatin (dye) toners, will change the colour of the paper as well. Even substances like tea or coffee (essentially dye toners) can be used, and sometimes multiple toning, for a variety of split-tone effects is possible.

All VC papers can be toned, although the FB's tend to be more consistent - but <u>only</u> if they have been properly washed. The warm-tone chloro-bromide VC's will tend to produce the most vivid colours, which are often too strong for my liking, and hence one reason for my preference for Multigrade.

Whatever the toning process, it pays to think about it prior to film exposure. It affects the way we need to make our VC prints: even if they look perfectly balanced before toning, changes in physical and optical contrast after toning can easily upset the balance of the image.

The simplest toners are the one-bath, or monobath varieties. The fixed and washed image is put into the solution until the desired effect is achieved, progress being judged with the lights on. Two bath toners usually comprise a separate bleach and toning solution. The control they afford is usually greater, since the degree of bleaching can be altered to suit the image. The bleach works on the image highlights first. This makes it possible to introduce colour just into those areas for a split-tone effect. This can be subtle, to make a neutral-tone paper, such as Multigrade, look like a warm or cold-

tone paper, or it can be more pronounced in effect. Alternatively, for a really strong effect, the print can be fully bleached-back in the first solution, rinsed until all the bleach's yellow stain has gone and toned to put colour into all the image. Most toners change the silver of the image into another chemical, for example silver-selenide after selenium toning. However, the recently reintroduced FSA (formamidine sulphinic acid) toner works by redeveloping the silver (see: REDEVELOPMENT).

Multiple toning of VC's is possible with some solutions. The sequence of toning is important: blue should always follow sepia, or it might be washed out. Gold and selenium usually follow sepia ; if used first, their protective capability will restrict the action of other toners. Dye toners are used after chemical.

The most popular toner is selenium. Used dilute (Kodak toner diluted 1+19) it will merely archive the image, creating an invisible protective silver-selenide layer. Used stronger (1+9 or more), it will also increase D-max, whilst with the warm-tone papers it can produce a split-tone, of purple shadows and neutral grey mid-tones/highlights. Like all photo solutions it should be used with care, with gloves or tongs and ideally with good ventilation.

Very often I will make prints with fogged highlights, to provide some silver for a chemical toner to work on. In their b&w state, such prints often looked veiled and flat, but introduce just a little colour into those 'highlights' and the effect of optical colour contrast, of image colour against image tone, can really lift the image.

With the exception of selenium, I make all my own toners (see: FORMULARY, CREATIVE ELEMENTS). Partly this is for reasons of cost, most importantly it is for control: I know what's going into the solution, chemical alterations are then possible for full effect. The cost saving of making our own stops us overworking a toner; a commercial kit may claim to tone a specified number of prints, but does it tone them all the same? No. Toners change with use, and with repeated use.

For the most predictable results, I tend to view the toned print, first under a daylight viewing bulb and then under a normal household tungsten light as well (see: DARKROOM EQUIPMENT). Judging the required amount of toning can be hard, especially with matt and semi-matt papers which tend to dry-down more, causing the colour to flatten off.

Finally, water quality can affect the success of a toner. Blue toners in particular don't like alkali water, the same can be said of selenium and variable sepia which may pick up scum marks. However, it does improve wash efficiency (see: WASHING).

Redevelopment

The process - emulating other makes of paper - techniques

It may not always be possible to get the desired image colour through development of VC's alone, for example with the neutral-tone papers. We then have the option to tone the print, or to redevelop it.

Redevelopment usually takes place after the image has been fixed and properly washed: like toning, we don't want any residual fixer left in the paper to combine with the bleaching agent.

First the image is bleached. After a brief wash it is then possible to redevelop the image to a variety of colours, some quite subtle in tone, others more pronounced in effect. The degree of change can be controlled through the extent of bleaching, the type of bleach and the chosen redeveloper. It is possible to make neutral-tone papers mimic warm and cold-tone varieties without the expense of buying them.

Apart from the Speedibrews FSA 'toner', there are no redevelopment kits that I know of. I make my own. Most of the ingredients are used in conventional print developers and bleaches, so there should be little need to purchase any new stocks. In most cases, commercial warm and cold-tone developers do not work as well. For example, the cold-tone redevelopment formula I use contains just one developing agent, the soft working metol. If a proprietary cold-tone developer were used, undoubtedly it would also need to contain a harder working agent, such as hydroquinone, which would lessen the colour effect. Similarly, most of the redeveloper formulary won't work as original developers, as they are formulated to work on an already developed but bleached image.

Once redeveloped and washed, it is possible to tone the print for a wider range of effects. For example, Multigrade does not normally change much in colour with selenium, but, redeveloped to a cool blue-black, it can be cooled-off even more with selenium, the same can be said of gold. Incidentally, redevelopment won't change the base colour of the paper. Only gelatin dye toners, or improper processing (staining) will do that.

All VC's will respond to redevelopment, although the warm-tone papers usually demonstrate the widest range of effects.

Washing

Times - hypo-clearing agents - washing problems - the controls

Unlike development or toning (and unless we use a wash efficiency testing solution, like Kodak's HT2) there is little visual indication of the effectiveness or completeness of the wash process. For example, I remember being proudly told by a gallery proprietor how most of their images were toned (with archival considerations in mind), yet there was no mention as to whether the same images were washed: in that case only time would tell.

VC paper wash requirements are no different to graded papers. RC's need just 3-4 minutes in fresh, running water (too much longer and some brands will irrevocably curl). FB's need a minimum of an hour, or less if hypo-cleared. These times are for water at 20C.

Straight, plain water washing can be divided into two stages. The first stage sees the fairly rapid removal of most of the fixer, whilst the second involves the replacement of the remaining thiosulphate (fixer) by ions in the water. The process relies on an adequate supply of fresh water so that chemistry within the emulsion and the support material can diffuse out into it until a balance between the two is reached. If the wash water is replaced with fresh, the process will continue (theoretically) until the desired residual chemistry level has been reached. However, FB's may not be washed to absolute archival standards, i.e. containing a residual thiosulphate (fixer) level of $0.01g/m^2$, if washed for the normal time in very soft water, or without the use of a hypo-clear, or if the image has been over-fixed, or fixed in an overworked fixer that contains too much soluble silver. However, it is now agreed that the small trace of residual thiosulphate just mentioned is beneficial to the permanence of the image since it combines with the silver image to form an invisible, protective silver-sulphide layer as mentioned in sepia toning below.

Hypo eliminators that oxidise all residual thiosulphate to a more water soluble state, are not recommended since they enable the complete removal of the fixer and may actually damage the paper. However, it is a good idea with all VC FB's to use a hypo-clearing agent, such as Ilford's Washaide, or a simple solution of sodium sulphite or sodium carbonate. This treatment is applied after the image has been fixed and washed for about 10-15 minutes to help rid it of most of the fixer solution. These solutions not only reduce washing times by up to 50%, they also improve the efficiency of cold water washing, in the winter when the water may drop to as low as 2-3C. They also help to improve wash efficiency in soft water areas where the water has a relatively low salt content. Hard water, with a higher salt content, is better for washing, in particular the alkali carbonates are most useful.

Failure to wash a print properly, to rid it of a sufficient amount of fixer, can seriously affect any toning: it may irreversibly lighten the print when it is in the toner's bleach (most noticeably in the highlights), also it can stain the paper, for example when selenium toning. Once dry, too much fixer left in a print will gradually convert the silver to visibly changed silver sulphide, creating a brown, often patchy, discoloured image. Interestingly, sepia toning is an accelerated version of this process, which takes the print to a more stable state, but which is intended to create a more uniform silver sulphide image that is stabilised from further 'decay' by proper washing after toning.

Print washers aren't a necessity for any paper. A dish, or a dish with a tray syphon, will suffice. However, archival washers that hold each print apart, in individual vertical wash chambers, do make the job easier and less time consuming than manually rotating prints and regularly draining the dish. They also reduce the risk of print damage from too much handling as with dish washing and as with some other washer designs.

Print washing is best carried out at 20C. Any warmer and the emulsion can become softened, especially those of the warm-tone papers, resulting in possible physical damage especially after any alkali toning processes that temporarily swell and further soften the emulsion, such as thiocarbamide toning. Colder than 20C and the wash time will need to be extended accordingly. Below about 10C, without the use of a hypo-clear, the wash may, in fact, not to be archival, no matter how long it is, and toning efficiency will be affected. At 20C my normal print wash time for a double weight FB, using a Nova archival washer, is one and a half hours. The use of a hypo-clear will halve this time. If the print is to be toned, I normally wash it completely, then tone it and then wash it for the same time again. A paper like Multigrade won't be physically affected by this prolonged wash sequence, warmer tone, softer emulsion papers might be.

Drying and finishing

Air or heat drying - retouching - flattening - techniques

Drying FB's is never easy and VC FB's are no exception. I would avoid heat drying using any sort of contact method such as a drum or flat-bed drier. The emulsion, especially of toned (perhaps temporarily softened) prints can stick to their canvas blankets, in particular the more delicate warm-tone chloro-bromide emulsions. Better to air-dry prints on a line, with a peg at each corner, hanging two prints back-to-back so that they dry flatter, or lay them on fibreglass mesh screens. The mesh can be bought by the square metre and stretched across a frame.

Drying screens, unlike photo blotters, are washable. This helps to prevent possible contamination from any residual chemistry in improperly washed, previously dried prints. Screens also dry prints much quicker.

I prefer to lay the paper with the emulsion-side facing up when I dry prints on screens. This eliminates the possibility of the mesh marking the image, however it will cause the print to curl more as it dries. The slower the print is dried, i.e. the cooler the drying environment, the less it will curl, whilst a warmer atmosphere will leave air-dried glossy unglazed papers with a shinier surface and warm-tone papers with a warmer image colour. Incidentally, I never squeegee any toned prints prior to drying as they can be marked.

The only heat drying method I use is a flatbed drier for assessing briefly washed VC FB proofs and test-strips. A hair drier, or similar, or even a microwave, is useful for the same purpose. Rapidly drying proofs in this way provides useful dry-down information although it may warm image colour slightly with the warm-tone VC papers, as mentioned above.

The photographic process doesn't end at the drying stage. There are the important considerations of retouching and how to present the image to be thought about. Too often prints look incomplete because of a lack of attention to such detail.

Retouching VC FB's is quite easy. Their absorbent emulsion surfaces take spotting and hand colouring dyes, whilst the matt and semi-matt finishes also take watercolour pigments, and all much better than their plastic RC counterparts. VC FB's can even be etched with a sharp scalpel to remove unwanted blemishes and fine detail, when bleaching wouldn't be possible.

For me, retouching goes beyond the removal of marks caused by dirt and possible damage to the negative, or from dust on the negative carrier. I'll remove any unwanted detail in the scene that conflicts with the intention of the image. Looking at the print upside down helps to see such marks more easily as the eye no longer sees a recognisable image but merely a selection of shapes and tones in abstract relation to each other. Very often I'll take an hour or so to retouch a 20"x16" print, gradually working my way across the image, tidying it up, trying to simplify it, removing unwanted information - decoding it as it were - to give a truer meaning. Some prints take less time - the less detailed variety.

Much of my retouching work comes about through the use of the 35mm format. The high degree of negative magnification reveals every tiny spec of dust on the negative and glass over-carrier, whilst its grainier image breaks up finer detail to make it look less like detail and more like a series of mistakes which may also need retouching.

Retouching a VC print, usually with a very fine 0000 brush, I always make sure the brush is damp and not wet with the spotting medium. Too much solution on the brush and there is the distinct possibility of a drying mark being left on the print. Better to apply the solution little by little, in gradual stages. My usual technique is to test the brush on a spare piece of paper, rolling the tip to take off the excess solution. I will work on the less obvious marks first and then on the finer detail as the brush becomes drier. If I'm unsure about the presence of a mark, or some bright eye-catching highlight detail, I'll ask myself: "Would I put it there out of choice? If I were painting the same scene, would I add such a detail? Does it improve the image or detract from it?" If I'm in any doubt I'll remove it.

Usually I'll flatten the print first before spotting. I use a dry-mounting press, set at about 70C, into which the dry print is placed between two sheets of 4-ply museum mounting board, which have been pre-heated to drive out excess moisture that might cause the card and print to stick together. I put the print in the press briefly: about 15 seconds is long enough just to warm the paper but not to make it hot. I then leave it to cool on a clean flat surface under a weight. If you don't have a press, lightly spraying the back of a VC FB print with water, using a fine-spray plant mister, followed by drying between clean photographic blotters works extremely well.

Filter settings for VC papers

At the time of going to press, filtration information was not available for two new papers - Kodak's Polymax Fine-Art and Oriental's VC FB Warm. Provided here are the filter settings for the other papers currently available.

Dial-in filtration with colour heads uses yellow and magenta filter values. These can be used independently (i.e. yellow or magenta on their own), or combined to provide consistent exposure times between grades 0 to $3^1/_2$. When used together, the addition of yellow or magenta filtration acts as a neutral density filter that balances print exposures throughout the range, with a doubling of times for grades 4 to 5. The advantage of the yellow or magenta system is that it gives shorter print exposures but at the expense of having to work out revised exposure times for every grade setting. Note that not all the manufacturers supply information on both methods. Ilford Mutligrade settings can be used for Sterling's Premium F VC FB and Forte's Polywarmtone.FB.

When working with VC papers, it is especially important to use the right safelight: Ilford's 902, Kodak's OC or a dark red filter, e.g. Ilford's 906, or the equivalent filter type.

Agfa Multicontrast Classic FB

		Kodak CP or CC filters		Durst colour mixing head
Grade	0	80Y	0	60Y
	1	30Y	1	25Y
	2	10M	2	10M
	3	50M	3	30M
	4	110M	4	60M
	5	200M	5	130M

Ilford Mutligrade FB

		Kodak		Durst colour mixing head
Grade	00	199Y	00	150Y
	0	90Y	0	90Y
	1	50Y	1	55Y
	2	0	2	0
	3	25M	3	45M
	4	80M	4	100M
	5	199M	5	170M

Kentmere FB

	Kodak		Durst colour mixing head
0	80Y	0	40Y
1	45Y	1	15Y
2	10M	2	20M
3	45M	3	40M
4	75M	4	60M
5	130M	5	130M

Kentmere FB (combined filter settings)

	Kodak		Durst colour mixing head
0	80Y	0	40Y
1	60Y + 15M	1	25Y + 20M
2	35Y + 50M	2	10Y + 45M
3	15Y + 70M	3	5Y + 50M
4	5Y + 85M	4	60M
5	130M	5	130M

Oriental Select FB

	Kodak		Durst colour mixing head
0	80Y	0	110Y
1	30Y	1	70Y
2	0	2	0
3	40M	3	45M
4	100M	4	95M
5	200M	5	170M

Testing papers

Product information - conducting our own tests - what to look for in a paper

What do we look for in a paper? How do we find out about their various strengths and weaknesses, to discover which one might be the right one for us? How can we get the best results from them?

We can get much of this information from magazine test reviews and manufacturers' product information sheets, but individual requirements, subjective opinions and even personal prejudices can leave much to be answered. So, testing papers for ourselves, as outlined below, is usually the best provider of information.

I get most of my information from making a series of simple step-wedge tests, contact-printing a transmission step tablet, such as Agfa's, onto the paper and processing it as normal, or differently, depending on what it is I want to find out. The tablet is a strip of film graduated into 19 steps of increasing density. Each step up the scale transmits half a stop less light than the previous one. Once processed, these step-wedges provide information that is relative to other papers tested in the same way. Because of their objective nature, they are a better way of evaluating a paper than using a favourite negative, which has subjective and emotional values, that may suit one paper better than another.

The printed step-wedges can be cut in half, so that one piece can be toned, or washed for much longer, or dried differently, to compare any differences when dry. The advantage of cutting them in half, lengthways, after fixing is that the density and tonal range of each half is identical prior to further treatment. Once dry, the two halves can be put side by side for comparative evaluation so that if, for example, the toned half shows a one step (half a stop) loss of highlight density then we know, in future, to increase print exposure by a $+^1/_2$ stop for that process. Likewise, if we notice a one step loss, or blocking up, of shadow detail, perhaps after high concentration selenium toning, that intensifies the blacks, than we know that in future it will be necessary to print a half grade softer, to keep the shadow detail more open.

These wedges also depict the tonal range of a paper, showing quite clearly how well it renders and separates shadow and highlight densities. They also show how tonal range is affected by push and pull processing. Comparing them with tests made on other papers may reveal some interesting differences. They can even be used to demonstrate the results of split-grading, flashing and fogging.

Once tested, it is important to remember that any paper will only be as good as the negative printed onto it. With this thought in mind, we should always be prepared to criticise the quality of our negatives before blaming a paper. Also, constantly switching from one paper to another, for example to get subtle changes in image colour, is often not the best policy, since toning or redevelopment should be able to do the job - and without the added expense of purchasing another make of paper. Besides, unless we use a lot of paper, having several boxes of different makes sitting around for a long time runs the risk of their ageing. In particular, unprocessed warm-tone papers gradually lose their warmth of tone.

Some of the things I like to know about a paper include:

Emulsion type: is it warm or neutral-toned? How will it respond to methods of warm and cold-tone development, toning and redevelopment?

Spectral sensitivity: what enlarger filtration and safelighting suits it best?

Speed: how much exposure does it need and will it be slower than other papers? Which grades require more exposure?

Contrast range: will it give me a proper grade 0 to grade 5?

Tonal range: is it likely to provide good shadow and highlight separation?

Emergence time: how long does it take for the image to appear in the developer so that I can use the factoral method of development?

Minimum and maximum development factors/times: how much can I pull a warm-tone paper to warm image colour further, or to reduce contrast without losing density or getting an uneven image? Can I pull the paper to compensate for accidental over-exposure? How much can I push it, to cool image colour and to increase contrast?

Batch consistency: is the speed of different boxes the same; will toned prints from different batches exhibit the same colour?

Physical durability: can it stand up to prolonged processing without the edges frilling, or the paper becoming discoloured?

How it dries: will differences in drying temperature affect image colour or the glossiness of the finish?

Retouchability: what methods can I use?

The different makes

RC versus FB - emulsion types - image colour and toning

In brief, the different types of VC papers can be divided into four basic groups: resin-coated, fibre-based, the warm-tone chloro-bromides and the neutral-tone chloro-bromides/bromo-chlorides.

Traditionally the FB's have been the preferred choice for quality, but nowadays there is not a huge difference between them and the RC's. Certainly, if washing facilities and time are limited then my choice would be RC, especially if prints are to be toned, since any residual fixer in the paper (due to insufficient washing) will combine with the bleaching agent contained in most toners. The effect will then be to permanently lighten the print. However, if you have the time to wash FB's, they undoubtedly possess a finer aesthetic quality, that can be best described as being more tactile in appearance.

My own preference remains with the FB's and in particular with Ilford Mutligrade matt. In part this preference is because I sell my prints and for this the physical, more appealing aspect of FB's seems to help. Also because I employ a lot of local bleaching work, as I have mentioned already, FB prints offer more control in this respect.

Another difference between RC's and FB's (which no longer applies) relates to their archival permanence. In the early days of RC's it was true that their laminated construction was more susceptible to breaking down, but this is really no longer true, such are the improvements in manufacturing. In fact, I would expect to see more RC VC prints around in the years to come, quite simply because they are easier to archivally wash than their FB counterparts. Whilst on the subject of permanence, it is thought the less fine grain neutral-tone papers are less susceptible to chemical decay, e.g. via pollutants, than the warm-tone papers,

The other major difference between VC's is their emulsion type. As mentioned above, they can be divided into warm-tone chloro-bromides and neutral-tone chloro-bromides/bromo-chlorides. The former will produce a warm image colour upon development, without toning, which is usually a slight brown/olive-brown in tone. This image colour can be further enhanced through methods of development,

whether it be through the use of a warm-tone developer or a short development time, or both. The image colour of the warm-tone papers can also be neutralised through the use of a cold-tone developer and can even be made to turn slightly cool through the use of a cold-tone developer/development routine, as mentioned in DEVELOPMENT.

The neutral-tone papers will not respond so readily to this type of direct image control. If we wish to alter their colour then we must tone or redevelop them. However, the neutral-tone papers have always produced higher maximum contrast, being capable of a true grade 5.

As far as toning is concerned, the warm-tone papers will produce the most vivid colours, which in my opinion can often be a little too colourful. However, if you wish to selenium split-tone a print, to produce purple shadows and neutral grey mid-tones and highlights, then only the warm-tone papers will work. Gold toning a warm-tone paper will shift the image colour towards a cool blue, more than for the nuetral-tone papers.

Some of the warm-tone papers also have off-white base colours, to add to the warmth of their image tone, but the various differences between them, including all the surface types, is beyond the scope of this piece (see below).

As far as handling is concerned, the neutral-tone papers tend to have tougher emulsions, so they are less likely to be marked when toned or during drying. Although, that said, I would never recommend any kind of contact drying method for any toned print, irrespective of its emulsion type.

At the time of writing the FB VC papers available included:

Warm-tone - Agfa Multicontrast Classic, Sterling Premium F VC and Forte Polywarmtone. I also received samples of a warm-tone VC manufactured by Oriental late in the book's production schedule.

Neutral-tone: Ilford Multigrade, Kentmere Fibre-Base VC and Oriental Select. Samples of Kodak Polymax Fine-Art also arrived just prior to publication.

It was our intention to provide a review of all the various different makes of VC, but the arrival of the two new papers at the end of the production period left insufficent time to test them. Leaving them out would have instantly dated the book, so, instead, we intend to publish a full review of them all as an Ag+ photographic supplement, due out in early 1995.

In the meantime if you wish to find out more about FB and RC VC papers, or wish to purchase any, they are available from Luminos Corporation, PO Box 158, Yonkers, NY 10705.
Telephone 1-800-LUMINOS.

f. stop table

-1.00	-0.75	-0.50	-0.25	Time	0.25	0.50	0.75	1.00	1.25	1.50	1.75	2.00	2.25	2.50	2.75	3.00
0.5	0.6	0.7	0.8	1.0	1.2	1.4	1.7	2.0	2.4	2.8	3.4	4.0	4.8	5.7	6.7	8.0
1.0	1.2	1.4	1.7	2.0	2.4	2.8	3.4	4.0	4.8	5.7	6.7	8.0	9.5	11.3	13.5	16.0
1.5	1.8	2.1	2.5	3.0	3.6	4.2	5.0	6.0	7.1	8.5	10.1	12.0	14.3	17.0	20.2	24.0
2.0	2.4	2.8	3.4	4.0	4.8	5.7	6.7	8.0	9.5	11.3	13.5	16.0	19.0	22.6	26.9	32.0
2.5	3.0	3.5	4.2	5.0	5.9	7.1	8.4	10.0	11.9	14.1	16.8	20.0	23.8	28.3	33.6	40.0
3.0	3.6	4.2	5.0	6.0	7.1	8.5	10.1	12.0	14.3	17.0	20.2	24.0	28.5	33.9	40.4	48.0
3.5	4.2	4.9	5.9	7.0	8.3	9.9	11.8	14.0	16.6	19.8	23.5	28.0	33.3	39.6	47.1	56.0
4.0	4.8	5.7	6.7	8.0	9.5	11.3	13.5	16.0	19.0	22.6	26.9	32.0	38.1	45.3	53.8	64.0
4.5	5.4	6.4	7.6	9.0	10.7	12.7	15.1	18.0	21.4	25.5	30.3	36.0	42.8	50.9	60.5	72.0
5.0	5.9	7.1	8.4	10.0	11.9	14.1	16.8	20.0	23.8	28.3	33.6	40.0	47.6	56.6	67.3	80.0
5.5	6.5	7.8	9.2	11.0	13.1	15.6	18.5	22.0	26.2	31.1	37.0	44.0	52.3	62.2	74.0	88.0
6.0	7.1	8.5	10.1	12.0	14.3	17.0	20.2	24.0	28.5	33.9	40.4	48.0	57.1	67.9	80.7	96.0
6.5	7.7	9.2	10.9	13.0	15.5	18.4	21.9	26.0	30.9	36.8	43.7	52.0	61.8	73.5	87.5	104.0
7.0	8.3	9.9	11.8	14.0	16.6	19.8	23.5	28.0	33.3	39.6	47.1	56.0	66.6	79.2	94.2	112.0
7.5	8.9	10.6	12.6	15.0	17.8	21.2	25.2	30.0	35.7	42.4	50.5	60.0	71.4	84.9	100.9	120.0
8.0	9.5	11.3	13.5	16.0	19.0	22.6	26.9	32.0	38.1	45.3	53.8	64.0	76.1	90.5	107.6	128.0
8.5	10.1	12.0	14.3	17.0	20.2	24.0	28.6	34.0	40.4	48.1	57.2	68.0	80.9	96.2	114.4	136.0
9.0	10.7	12.7	15.1	18.0	21.4	25.5	30.3	36.0	42.8	50.9	60.5	72.0	85.6	101.8	121.1	144.0
9.5	11.3	13.4	16.0	19.0	22.6	26.9	32.0	38.0	45.2	53.7	63.9	76.0	90.4	107.5	127.8	152.0
10.0	11.9	14.1	16.8	20.0	23.8	28.3	33.6	40.0	47.6	56.6	67.3	80.0	95.1	113.1	134.5	160.0
10.5	12.5	14.8	17.7	21.0	25.0	29.7	35.3	42.0	49.9	59.4	70.6	84.0	99.9	118.8	141.3	168.0
11.0	13.1	15.6	18.5	22.0	26.2	31.1	37.0	44.0	52.3	62.2	74.0	88.0	104.7	124.5	148.0	176.0
11.5	13.7	16.3	19.3	23.0	27.4	32.5	38.7	46.0	54.7	65.1	77.4	92.0	109.4	130.1	154.7	184.0
12.0	14.3	17.0	20.2	24.0	28.5	33.9	40.4	48.0	57.1	67.9	80.7	96.0	114.2	135.8	161.5	192.0
12.5	14.9	17.7	21.0	25.0	29.7	35.4	42.0	50.0	59.5	70.7	84.1	100.0	118.9	141.4	168.2	200.0
13.0	15.5	18.4	21.9	26.0	30.9	36.8	43.7	52.0	61.8	73.5	87.5	104.0	123.7	147.1	174.9	208.0
13.5	16.1	19.1	22.7	27.0	32.1	38.2	45.4	54.0	64.2	76.4	90.8	108.0	128.4	152.7	181.6	216.0
14.0	16.6	19.8	23.5	28.0	33.3	39.6	47.1	56.0	66.6	79.2	94.2	112.0	133.2	158.4	188.4	224.0
14.5	17.2	20.5	24.4	29.0	34.5	41.0	48.8	58.0	69.0	82.0	97.5	116.0	137.9	164.0	195.1	232.0
15.0	17.8	21.2	25.2	30.0	35.7	42.4	50.5	60.0	71.4	84.9	100.9	120.0	142.7	169.7	201.8	240.0

Time																
15.5	18.4	21.9	26.1	31.0	36.9	43.8	52.1	62.0	73.7	87.7	104.3	124.0	147.5	175.4	208.5	248.0
16.0	19.0	22.6	26.9	32.0	38.1	45.3	53.8	64.0	76.1	90.5	107.6	128.0	152.2	181.0	215.3	256.0
16.5	19.6	23.3	27.7	33.0	39.2	46.7	55.5	66.0	78.5	93.3	111.0	132.0	157.0	186.7	222.0	264.0
17.0	20.2	24.0	28.6	34.0	40.4	48.1	57.2	68.0	80.9	96.2	114.4	136.0	161.7	192.3	228.7	272.0
17.5	20.8	24.7	29.4	35.0	41.6	49.5	58.9	70.0	83.2	99.0	117.7	140.0	166.5	198.0	235.5	280.0
18.0	21.4	25.5	30.3	36.0	42.8	50.9	60.5	72.0	85.6	101.8	121.1	144.0	171.2	203.6	242.2	288.0
18.5	22.0	26.2	31.1	37.0	44.0	52.3	62.2	74.0	88.0	104.7	124.5	148.0	176.0	209.3	248.9	296.0
19.0	22.6	26.9	32.0	38.0	45.2	53.7	63.9	76.0	90.4	107.5	127.8	152.0	180.8	215.0	255.6	304.0
19.5	23.2	27.6	32.8	39.0	46.4	55.2	65.6	78.0	92.8	110.3	131.2	156.0	185.5	220.6	262.4	312.0
20.0	23.8	28.3	33.6	40.0	47.6	56.6	67.3	80.0	95.1	113.1	134.5	160.0	190.3	226.3	269.1	320.0
20.5	24.4	29.0	34.5	41.0	48.8	58.0	69.0	82.0	97.5	116.0	137.9	164.0	195.0	231.9	275.8	328.0
21.0	25.0	29.7	35.3	42.0	49.9	59.4	70.6	84.0	99.9	118.8	141.3	168.0	199.8	237.6	282.5	336.0
21.5	25.6	30.4	36.2	43.0	51.1	60.8	72.3	86.0	102.3	121.6	144.6	172.0	204.5	243.2	289.3	344.0
22.0	26.2	31.1	37.0	44.0	52.3	62.2	74.0	88.0	104.7	124.5	148.0	176.0	209.3	248.9	296.0	352.0
22.5	26.8	31.8	37.8	45.0	53.5	63.6	75.7	90.0	107.0	127.3	151.4	180.0	214.1	254.6	302.7	360.0
23.0	27.4	32.5	38.7	46.0	54.7	65.1	77.4	92.0	109.4	130.1	154.7	184.0	218.8	260.2	309.4	368.0
23.5	27.9	33.2	39.5	47.0	55.9	66.5	79.0	94.0	111.8	132.9	158.1	188.0	223.6	265.9	316.2	376.0
24.0	28.5	33.9	40.4	48.0	57.1	67.9	80.7	96.0	114.2	135.8	161.5	192.0	228.3	271.5	322.9	384.0
24.5	29.1	34.6	41.2	49.0	58.3	69.3	82.4	98.0	116.5	138.6	164.8	196.0	233.1	277.2	329.6	392.0
25.0	29.7	35.4	42.0	50.0	59.5	70.7	84.1	100.0	118.9	141.4	168.2	200.0	237.8	282.8	336.4	400.0
25.5	30.3	36.1	42.9	51.0	60.6	72.1	85.8	102.0	121.3	144.2	171.5	204.0	242.6	288.5	343.1	408.0
26.0	30.9	36.8	43.7	52.0	61.8	73.5	87.5	104.0	123.7	147.1	174.9	208.0	247.4	294.2	349.8	416.0
26.5	31.5	37.5	44.6	53.0	63.0	75.0	89.1	106.0	126.1	149.9	178.3	212.0	252.1	299.8	356.5	424.0
27.0	32.1	38.2	45.4	54.0	64.2	76.4	90.8	108.0	128.4	152.7	181.6	216.0	256.9	305.5	363.3	432.0
27.5	32.7	38.9	46.2	55.0	65.4	77.8	92.5	110.0	130.8	155.6	185.0	220.0	261.6	311.1	370.0	440.0
28.0	33.3	39.6	47.1	56.0	66.6	79.2	94.2	112.0	133.2	158.4	188.4	224.0	266.4	316.8	376.7	448.0
28.5	33.9	40.3	47.9	57.0	67.8	80.6	95.9	114.0	135.6	161.2	191.7	228.0	271.1	322.4	383.4	456.0
29.0	34.5	41.0	48.8	58.0	69.0	82.0	97.5	116.0	137.9	164.0	195.1	232.0	275.9	328.1	390.2	464.0
29.5	35.1	41.7	49.6	59.0	70.2	83.4	99.2	118.0	140.3	166.9	198.5	236.0	280.7	333.8	396.9	472.0
30.0	35.7	42.4	50.5	60.0	71.4	84.9	100.9	120.0	142.7	169.7	201.8	240.0	285.4	339.4	403.6	480.0
30.5	36.3	43.1	51.3	61.0	72.5	86.3	102.6	122.0	145.1	172.5	205.2	244.0	290.2	345.1	410.4	488.0

The 'Time' column represents the basic print exposure time. As an example, plus 0.25 stops of exposure on a 10 second basic exposure time = 11.8 · 10 = 1.8 seconds. Minus 0.25 stops of exposure on a 10 second basic exposure time = 10 · 8.4 = 1.6 seconds.

Print magnification exposure table

Old \ New	130	140	150	160	170	180	190	200	210	220	230	240	250	260	270	280	290	300
120	1.17	1.36	1.56	1.78	2.01	2.25	2.51	2.78	3.06	3.36	3.67	4.00	4.34	4.69	5.06	5.44	5.84	6.25
130	1.00	1.16	1.33	1.51	1.71	1.92	2.14	2.37	2.61	2.86	3.13	3.41	3.70	4.00	4.31	4.64	4.98	5.33
140	0.86	1.00	1.15	1.31	1.47	1.65	1.84	2.04	2.25	2.47	2.70	2.94	3.19	3.45	3.72	4.00	4.29	4.59
150	0.75	0.87	1.00	1.14	1.28	1.44	1.60	1.78	1.96	2.15	2.35	2.56	2.78	3.00	3.24	3.48	3.74	4.00
160	0.66	0.77	0.88	1.00	1.13	1.27	1.41	1.56	1.72	1.89	2.07	2.25	2.44	2.64	2.85	3.06	3.29	3.52
170	0.58	0.68	0.78	0.89	1.00	1.12	1.25	1.38	1.53	1.67	1.83	1.99	2.16	2.34	2.52	2.71	2.91	3.11
180	0.52	0.60	0.69	0.79	0.89	1.00	1.11	1.23	1.36	1.49	1.63	1.78	1.93	2.09	2.25	2.42	2.60	2.78
190	0.47	0.54	0.62	0.71	0.80	0.90	1.00	1.11	1.22	1.34	1.47	1.60	1.73	1.87	2.02	2.17	2.33	2.49
200	0.42	0.49	0.56	0.64	0.72	0.81	0.90	1.00	1.10	1.21	1.32	1.44	1.56	1.69	1.82	1.96	2.10	2.25
210	0.38	0.44	0.51	0.58	0.66	0.73	0.82	0.91	1.00	1.10	1.20	1.31	1.42	1.53	1.65	1.78	1.91	2.04
220	0.35	0.40	0.46	0.58	0.60	0.67	0.75	0.83	0.91	1.00	1.09	1.19	1.29	1.40	1.51	1.62	1.74	1.86
230	0.32	0.37	0.43	0.48	0.55	0.61	0.68	0.76	0.83	0.91	1.00	1.09	1.18	1.28	1.38	1.48	1.59	1.70
240	0.29	0.34	0.39	0.44	0.50	0.56	0.63	0.69	0.77	0.84	0.92	1.00	1.09	1.17	1.27	1.36	1.46	1.56
250	0.27	0.31	0.36	0.41	0.46	0.52	0.58	0.64	0.71	0.77	0.85	0.92	1.00	1.08	1.17	1.25	1.35	1.44
260	0.25	0.29	0.33	0.38	0.43	0.48	0.53	0.59	0.65	0.72	0.78	0.85	0.92	1.00	1.08	1.16	1.24	1.33
270	0.23	0.27	0.31	0.35	0.40	0.44	0.50	0.55	0.60	0.66	0.73	0.79	0.86	0.93	1.00	1.08	1.15	1.23
280	0.22	0.25	0.29	0.33	0.37	0.41	0.46	0.51	0.56	0.62	0.67	0.73	0.80	0.86	0.93	1.00	1.07	1.15
290	0.20	0.23	0.27	0.30	0.34	0.39	0.43	0.48	0.52	0.58	0.63	0.68	0.74	0.80	0.87	0.93	1.00	1.07
300	0.19	0.22	0.25	0.28	0.32	0.36	0.40	0.44	0.49	0.54	0.59	0.64	0.69	0.75	0.81	0.87	0.93	1.00
310	0.18	0.20	0.23	0.27	0.30	0.34	0.38	0.42	0.46	0.50	0.55	0.60	0.65	0.70	0.76	0.82	0.88	0.94
320	0.17	0.19	0.22	0.25	0.28	0.32	0.35	0.39	0.43	0.47	0.52	0.56	0.61	0.66	0.71	0.77	0.82	0.88
330	0.16	0.18	0.21	0.24	0.27	0.30	0.33	0.37	0.40	0.44	0.49	0.53	0.57	0.62	0.67	0.72	0.77	0.83
340	0.15	0.17	0.19	0.22	0.25	0.28	0.31	0.35	0.38	0.42	0.46	0.50	0.54	0.58	0.63	0.68	0.73	0.78
350	0.14	0.16	0.18	0.21	0.24	0.26	0.29	0.33	0.36	0.40	0.43	0.47	0.51	0.55	0.60	0.64	0.69	0.73
360	0.13	0.15	0.17	0.20	0.22	0.25	0.28	0.31	0.34	0.37	0.41	0.44	0.48	0.52	0.56	0.60	0.65	0.69
370	0.12	0.14	0.16	0.19	0.21	0.24	0.26	0.29	0.32	0.35	0.39	0.42	0.46	0.49	0.53	0.57	0.61	0.66
380	0.12	0.14	0.16	0.18	0.20	0.22	0.25	0.28	0.31	0.34	0.37	0.40	0.43	0.47	0.50	0.54	0.58	0.62
390	0.11	0.13	0.15	0.17	0.19	0.21	0.24	0.26	0.29	0.32	0.35	0.38	0.41	0.44	0.48	0.52	0.55	0.59
400	0.11	0.12	0.14	0.16	0.18	0.20	0.23	0.25	0.28	0.30	0.33	0.36	0.39	0.42	0.46	0.49	0.53	0.56
410	0.10	0.12	0.13	0.15	0.17	0.19	0.21	0.24	0.28	0.29	0.31	0.34	0.37	0.40	0.43	0.47	0.50	0.54
420	0.10	0.11	0.13	0.15	0.16	0.18	0.20	0.23	0.25	0.27	0.30	0.33	0.35	0.38	0.41	0.44	0.48	0.51
430	0.09	0.11	0.12	0.14	0.16	0.18	0.20	0.22	0.24	0.26	0.29	0.31	0.34	0.37	0.39	0.42	0.45	0.49
440	0.09	0.10	0.12	0.13	0.15	0.17	0.19	0.21	0.23	0.25	0.27	0.30	0.32	0.35	0.38	0.40	0.43	0.46
450	0.08	0.10	0.11	0.13	0.14	0.16	0.18	0.20	0.22	0.24	0.26	0.28	0.31	0.33	0.36	0.39	0.42	0.44
460	0.08	0.09	0.11	0.12	0.14	0.15	0.17	0.19	0.21	0.23	0.25	0.27	0.30	0.32	0.34	0.37	0.40	0.43
470	0.08	0.09	0.10	0.12	0.13	0.15	0.16	0.18	0.20	0.22	0.24	0.26	0.28	0.31	0.33	0.35	0.38	0.41
480	0.07	0.09	0.10	0.11	0.13	0.14	0.16	0.17	0.19	0.21	0.23	0.25	0.27	0.29	0.32	0.34	0.37	0.39
490	0.07	0.08	0.09	0.11	0.12	0.13	0.15	0.17	0.18	0.20	0.22	0.24	0.26	0.28	0.30	0.33	0.35	0.37
500	0.07	0.08	0.09	0.10	0.12	0.13	0.14	0.16	0.18	0.19	0.21	0.23	0.25	0.27	0.29	0.31	0.34	0.36

Changes in print exposure times, due to alterations of print size, are easily calculated using this exposure table. First, measure the length of the original print and find this value on the left-hand "Old" column. Now, find the "New" length on the top row. An exposure factor can now be found where their two lines of figures intersect.

310	320	330	340	350	360	370	380	390	400	410	420	430	440	450	460	470	480	490	500
6.67	7.11	7.56	8.03	8.61	9.00	9.51	10.03	10.58	11.11	11.67	12.25	12.84	13.44	14.06	14.69	15.34	16.00	16.67	17.36
5.69	6.06	6.44	6.84	7.25	7.67	8.10	8.54	9.00	9.47	9.95	10.44	10.94	11.46	11.98	12.52	13.07	13.63	14.21	14.79
4.90	5.22	5.56	5.90	6.25	6.61	6.98	7.37	7.76	8.16	8.58	9.00	9.43	9.88	10.33	10.80	11.27	11.76	12.25	12.76
4.27	4.55	4.84	5.14	5.44	5.76	6.06	6.42	6.76	7.11	7.47	7.84	8.22	8.60	9.00	9.40	9.82	10.24	10.67	11.11
3.75	4.00	4.25	4.52	4.79	5.06	5.35	5.64	5.94	6.25	6.57	6.89	7.22	7.56	7.91	8.27	8.63	9.00	9.38	9.77
3.33	3.54	3.77	4.00	4.24	4.48	4.74	5.00	5.26	5.54	5.82	6.10	6.40	6.70	7.01	7.32	7.64	7.97	8.31	8.65
2.97	3.16	3.36	3.57	3.78	4.00	4.23	4.46	4.69	4.94	5.19	5.44	5.71	5.98	6.25	6.53	6.82	7.11	7.41	7.72
2.66	2.84	3.02	3.20	3.39	3.59	3.79	4.00	4.21	4.43	4.66	4.89	5.12	5.36	5.61	5.86	6.12	6.38	6.65	6.93
2.40	2.56	2.72	2.89	3.06	3.24	3.42	3.61	3.80	4.00	4.20	4.41	4.62	4.84	5.06	5.29	5.52	5.76	6.00	6.25
2.18	2.32	2.47	2.62	2.78	2.94	3.10	3.27	3.45	3.63	3.81	4.00	4.19	4.39	4.59	4.80	5.01	5.22	5.44	5.67
1.99	2.12	2.25	2.39	2.53	2.68	2.83	2.98	3.14	3.31	3.47	3.64	3.82	4.00	4.18	4.37	4.56	4.76	4.96	5.17
1.82	1.94	2.06	2.19	2.32	2.45	2.59	2.73	2.88	3.02	3.18	3.33	3.50	3.66	3.83	4.00	4.18	4.36	4.54	4.73
1.67	1.78	1.89	2.01	2.13	2.25	2.38	2.51	2.64	2.78	2.92	3.06	3.21	3.36	3.52	3.67	3.84	4.00	4.17	4.34
1.54	1.64	1.74	1.85	1.96	2.07	2.19	2.31	2.43	2.56	2.69	2.82	2.98	3.10	3.24	3.39	3.53	3.69	3.84	4.00
1.42	1.51	1.61	1.71	1.81	1.92	2.03	2.14	2.25	2.37	2.49	2.61	2.74	2.86	3.00	3.13	3.27	3.41	3.55	3.70
1.32	1.40	1.49	1.59	1.68	1.78	1.88	1.98	2.09	2.19	2.31	2.42	2.54	2.66	2.78	2.90	3.03	3.16	3.29	3.43
1.23	1.31	1.39	1.47	1.56	1.65	1.75	1.84	1.94	2.04	2.14	2.25	2.36	2.47	2.58	2.70	2.82	2.94	3.06	3.19
1.14	1.22	1.29	1.37	1.46	1.54	1.63	1.72	1.81	1.90	2.00	2.10	2.20	2.30	2.41	2.52	2.63	2.74	2.85	2.97
1.07	1.14	1.21	1.28	1.36	1.44	1.52	1.60	1.69	1.78	1.87	1.96	2.05	2.15	2.25	2.35	2.45	2.56	2.67	2.78
1.00	1.07	1.13	1.20	1.27	1.35	1.42	1.50	1.58	1.66	1.75	1.84	1.92	2.01	2.11	2.20	2.30	2.40	2.50	2.60
0.94	1.00	1.06	1.13	1.20	1.27	1.34	1.41	1.49	1.56	1.64	1.72	1.81	1.89	1.98	2.07	2.16	2.25	2.34	2.44
0.88	0.94	1.00	1.06	1.12	1.19	1.26	1.33	1.40	1.47	1.54	1.62	1.70	1.78	1.86	1.94	2.03	2.12	2.20	2.30
0.83	0.89	0.94	1.00	1.06	1.12	1.18	1.25	1.32	1.38	1.45	1.53	1.60	1.67	1.75	1.83	1.91	1.99	2.08	2.16
0.78	0.84	0.89	0.94	1.00	1.06	1.12	1.18	1.24	1.31	1.37	1.44	1.51	1.58	1.65	1.73	1.80	1.88	1.96	2.04
0.74	0.79	0.84	0.89	0.95	1.00	1.06	1.11	1.17	1.23	1.30	1.36	1.43	1.49	1.56	1.63	1.70	1.78	1.85	1.93
0.70	0.75	0.80	0.84	0.89	0.95	1.00	1.05	1.11	1.17	1.23	1.29	1.35	1.41	1.48	1.55	1.61	1.68	1.75	1.83
0.67	0.71	0.75	0.80	0.85	0.90	0.95	1.00	1.05	1.11	1.16	1.22	1.28	1.34	1.40	1.47	1.53	1.60	1.66	1.73
0.63	0.67	0.72	0.76	0.81	0.85	0.90	0.95	1.00	1.05	1.11	1.16	1.22	1.27	1.33	1.39	1.45	1.51	1.58	1.64
0.60	0.64	0.68	0.72	0.77	0.81	0.86	0.90	0.95	1.00	1.05	1.10	1.16	1.21	1.27	1.32	1.38	1.44	1.50	1.56
0.57	0.61	0.65	0.69	0.73	0.77	0.81	0.86	0.90	0.95	1.00	1.05	1.10	1.15	1.20	1.26	1.31	1.37	1.43	1.49
0.54	0.58	0.62	0.66	0.69	0.73	0.78	0.82	0.86	0.91	0.95	1.00	1.05	1.10	1.15	1.20	1.25	1.31	1.36	1.42
0.52	0.55	0.59	0.63	0.66	0.70	0.74	0.78	0.82	0.87	0.91	0.95	1.00	1.05	1.10	1.14	1.19	1.25	1.30	1.35
0.50	0.53	0.56	0.60	0.63	0.67	0.71	0.75	0.79	0.83	0.87	0.91	0.96	1.00	1.05	1.09	1.14	1.19	1.24	1.29
0.47	0.51	0.54	0.57	0.60	0.64	0.68	0.71	0.75	0.79	0.83	0.87	0.91	0.96	1.00	1.04	1.09	1.14	1.19	1.23
0.45	0.48	0.51	0.55	0.58	0.61	0.65	0.68	0.72	0.76	0.79	0.83	0.87	0.91	0.96	1.00	1.04	1.09	1.13	1.18
0.44	0.46	0.49	0.52	0.55	0.59	0.62	0.65	0.69	0.72	0.76	0.80	0.84	0.88	0.92	0.96	1.00	1.04	1.09	1.13
0.42	0.44	0.47	0.50	0.53	0.56	0.59	0.63	0.66	0.69	0.73	0.77	0.80	0.84	0.88	0.92	0.96	1.00	1.04	1.09
0.40	0.43	0.45	0.48	0.51	0.54	0.57	0.60	0.63	0.67	0.70	0.73	0.77	0.81	0.84	0.88	0.92	0.96	1.00	1.04
0.38	0.41	0.44	0.46	0.49	0.52	0.55	0.58	0.61	0.64	0.67	0.71	0.74	0.77	0.81	0.85	0.88	0.92	0.96	1.00

For example, an exposure time of 10 seconds for a print 200mm in length, is now 14.4 seconds (10 x 1.44) for a print with a new length of 240mm.

Note: this table will not work for some condenser enlargers. For example, whose lightsource cannot be adjusted to give the same area of coverage over the lens as print size (and lens/bellows extension) changes.